RED RIDING HOOD'S
Real Life

RED RIDING HOOD'S
Real Life

A NOVEL IN VERSE

LANA HECHTMAN AYERS

NIGHT RAIN PRESS

FIRST EDITION

Printed in the United States of America
ISBN 978-0-9970834-7-7

Cataloging Information: 1. Ayers, Lana Hechtman;
2. Contemporary American Poetry; 3. Novel in Verse;
4. Fairy Tales; 5. Red Riding Hood; 6. Baba Yaga; 7. Wolf.

Original Cover Art: Marie Fox, *Morning With Matisse*,
oil on canvas, 24 x 30.

Author Photo: Andrew E. Ayers.

Layout/Design by Tonya Namura using
Guess Sans, Guess Pro, and Gentium Basic.

Night Rain Press, an imprint of Night Rain Books.

Night Rain Press
PO Box 445
Tillamook, OR 97141

Contact the author at Night.Rain.Press@gmail.com

for Andy with more than fairy tale love—
absolutely the real thing

TABLE OF *Contents*

PROLOGUE: THE FIRST STORY 3

CHAPTER I: ONCE UPON
RED RIDING HOOD BEGINS A NEW DIARY 7
RED RIDING HOOD DREAMS OF ANOTHER WINTER 9
RED RIDING HOOD WORRYING OVER GRETEL 12
RED RIDING HOOD TALKS ABOUT HER MOTHER 14
RED RIDING HOOD AS WILD CHILD 17
RED RIDING HOOD AT SIXTEEN 19
RED RIDING HOOD DIARIES ABOUT
 LOSING HER VIRGINITY 21
NOTES ABOUT THE HUNTER IN THIS VERSION OF
 THE FAIRY TALE 22
RED RIDING HOOD DREAMS OF THE FATHER
 SHE CAN'T REMEMBER 24
BABA YAGA ADVISES RED RIDING HOOD 26

CHAPTER II: DOMESTICITY
RED RIDING HOOD AT THE ALTAR WITH HUNTER 31
RED RIDING HOOD ON DOMESTICITY 33
RED RIDING HOOD ENDS UP WITH HUNTER 34
HUNTER INSISTS ON HAVING HIS SAY 36
RED RIDING HOOD ON DISCOVERING HER
 HUSBAND'S MAGIC MIRROR 38
RED RIDING HOOD DIARIES ABOUT SEX WITH
 HUSBAND HUNTER 39
RED RIDING HOOD AT HER JOB AT THE DAYCARE 40

RED RIDING HOOD WONDERS ABOUT
 SUPERMAN'S CAPE 42
RED RIDING HOOD AT THE GROCERY STORE 44

CHAPTER III: WHAT BIG TEETH

RED RIDING HOOD'S REAL FIRST ENCOUNTER WITH
 THE WOLF 49
THE WOLF TELLS RED RIDING HOOD ABOUT THE
 PAINTING *SALOME OF THE SEVEN VEILS* 51
WHAT THE WOLF WHISPERED TO RED DURING
 THEIR FIRST ENCOUNTER 53
RED RIDING HOOD AND THE WOLF
 DISCUSS ROTHKO 54
THE WOLF AND RED RIDING HOOD CONSIDER
 THE PAINTING *MAN SHAVING* 55
RED RIDING HOOD AND THE WOLF VIEW
 CHAGALL'S LA LECON DE PHILETAS 56
THE WOLF ENTERS RED RIDING HOOD'S DIARY 59
THE WOLF REFLECTS ON HIS FIRST MEETING
 WITH RED RIDING HOOD 60
RED RIDING HOOD DREAMS OF THE WOLF 61

CHAPTER IV: THE PLOT QUICKENS

RED RIDING HOOD MEETS THE WOLF A
 SECOND TIME 65
AFTER THEIR SECOND MEETING, THE WOLF
 REFLECTS ON RED RIDING HOOD'S CAPE 67
RED RIDING HOOD AND THE WOLF BEFORE
 IT IS TOO LATE 68
WHAT RED RIDING HOOD REALIZES 70
RED RIDING HOOD ON SEDUCTION 71
THE WOLF THE MORNING AFTER 73
RED CHIDES HERSELF UPON WAKING IN
 GRANDMA'S BED ALONE 75

CHAPTER V: MYTHS

THE WOLF ADMITS TO CROSS-DRESSING 79
RED RIDING HOOD AFTER A SECOND TRYST 80
RED RIDING HOOD ASKS HER DIARY ABOUT SIN 82
RED RIDING HOOD CONFIDES IN GRANDMA 84
RED RIDING HOOD DISPELS THE MYTH OF
 WHAT BIG TEETH 85
THE WOLF SHATTERS A MYTH OR TWO HIMSELF 87
GRETEL ADVISES RED RIDING HOOD 89
HUNTER WONDERS WHERE HIS WIFE GOES
 AFTER WORK 90

CHAPTER VI: IF THE S(K)IN FITS

RED RIDING HOOD FOR REAL 93
RED RIDING HOOD AFTER MEETING THE WOLF A
 THIRD TIME 94
RED RIDING HOOD ON GENTRIFICATION 95
THE MOMENT RED KNEW 97
RED RIDING HOOD'S DIARY FRAGMENT FROM
 THE FIREPLACE 99
THE WOLF ADMITS HIS WEAKNESS 100
RED RIDING HOOD TAKES TO THE EASEL 101
THE WOLF RELATES THE TALE OF PHILOMEL 103
RED RIDING HOOD PAINTS WHILE THE
 WOLF SLEEPS 106
RED RIDING HOOD GOES COAT SHOPPING 108

CHAPTER VII: STICKS & STONES

"RED RIDING HOOD KISSES, TELLS ALL" 115
RED RIDING HOOD ON BEING TALKED ABOUT 116
STICKS & STONES 117
FOUND OUT 119
RED RIDING HOOD'S APOLOGY 121

HUNTER'S MOMENT OF CLARITY 123

RED RIDING HOOD'S MOTHER BERATES HER 126

WHAT THE WOLF TOLD A BARTENDER ABOUT
 RED RIDING HOOD 129

CHAPTER VIII: A NEW RED

RED RIDING HOOD CONQUERS ANOTHER MYTH 133

RED RIDING HOOD MAKES LOVE TO THE CANVAS 135

RED RIDING HOOD'S SHOCKING DIARY ENTRY 136

THE WOLF GUESSES RED RIDING HOOD'S NEWS 137

RED RIDING HOOD PONDERS ALCHEMY 139

THE WOLF PUTS TWO MOONS IN HIS PAINTING
 RIVERS OF BABYLON 141

A NEW RED 142

THE WOLF'S NOBLE ACT 144

RED RIDING HOOD REFLECTS ON THE
 AFTERMATH 146

THE WOLF AFTER THE BREAK-UP 148

RED RIDING HOOD ATTEMPTS TO ENLIGHTEN
 PERRAULT 149

CHAPTER IX: THE CONTINUING SAGA

RED RIDING HOOD REMEMBERS GRANDMA 153

RED RIDING HOOD GOES DEEP INTO THE WOODS 154

RED RIDING HOOD ADMITS HER OWN
 COMPLACENCY 158

RED RIDING HOOD VISITS AN AQUARIUM 160

RED RIDING HOOD EMBRACES HER
 ARTIST ANIMUS 163

RED RIDING HOOD HOWLS IT LIKE IT IS 165

RED RIDING HOOD A YEAR INTO HER LIFE
 AS ARTIST 166

LONE WOLF TAKES OFF FOR PARTS UNKNOWN 168

HUNTER LANDS IN HOLLYWOOD 170

RED RIDING HOOD'S MOTHER FINALLY WRITES
 HER AN EMAIL 171
A YEAR AFTER RED RIDING HOOD LEFT HIM THE
 WOLF RECLAIMS HIS PALETTE 172
THE WOLF MOVES INTO THE SECOND STAGE
 OF GRIEF 174

CHAPTER X: EVER AFTER
RED RIDING HOOD AT HER SEASIDE CABIN 179
THE WOLF DISCOVERS HIS MUSE ANEW
 IN WALDPORT 181
RED'S FRIEND GRETEL FEEDS THE HUNGRY 184
BABA YAGA WAXES NOSTALGIC 187
RED RIDING HOOD AT THE CHEESE FACTORY
 (NOT A TRYST) 189
RED AND THE WOLF, AN AWKWARD
 RE-INTRODUCTION 192
IN THE PARKING LOT OF THE CHEESE FACTORY
 THE WOLF ASKS 194
RED SIDESTEPS THE WOLF'S REQUEST FOR
 EVER AFTER 198
RED DECIDES AT THE AIR MUSEUM 201
RED AND THE WOLF STROLL THE BEACH 204
RED RIDING HOOD ON THE SOUNDS OF A
 COMPANIONED LIFE 206

EPILOGUE: HAPPILY EVER AFTER 209

ACKNOWLEDGMENTS 215

GRATITUDE 219

ABOUT THE AUTHOR 221

Art is two things:
 a search for a road
 and a search for freedom.

(Alice Neel)

RED RIDING HOOD'S
Real Life

PROLOGUE: THE FIRST STORY

What would happen if one woman told the truth about
 her life?
The world would split open.
(Muriel Rukeyser)

The first story is not about light or apples.
The first story is about the woods,
the woman in the red hood, the Wolf.

About the path siren flowers lure you off of.
About leaving a trail only crows can follow.

The first story is about a witch, a bright house
made of gingerbread, which is to say, gluttony.
There are cinders in the hearth that sift to nothing.

Imagine hair long enough to climb, a mother's lies.
All stories are about innocence. All stories are about loss.

But the first story is about the glossy dark,
about what happens when
you close your eyes.

There is a fire in the woods.
Only Baba Yaga has the magic to call it forth.

Follow a trail of shattered bones
and scattered stones and you will find
her blind chicken-legged house.

Sift every poppy seed with your tongue by morning
and her magic will appear to become yours.

Beware appearances.
Once you have sown fire,
every story is about burning down.

But before this, the first story is about the dark.
Hark—the Wolf inhabits the dark.

When you close your eyes, he is there,
a river of teeth and claws.
He will tear you apart if you do not stop him.

Do not stop him.
How else to transform?

The first story is not about creation.
The first story is about the thatched dark.
Do not be so eager to light the match.

If you are cold, hold yourself close.
If you are hungry, eat desire.

If you are terrified, sing the fear to sleep.
The first story is about the big silence,
dark before illuminating words were spoken.

This is the first story.
This is our story. Close your eyes. Listen:

CHAPTER I
Once Upon

*Sometimes she walks through the village in her little red dress
all absorbed in restraining herself, and yet, despite herself,
she seems to move according to the rhythm of her life to come.*
(Rainer Maria Rilke, from "Child In Red"
translated by A. Poulin, Jr.)

RED RIDING HOOD BEGINS A NEW DIARY

There is something in me maybe someday / to be written;
now it is folded, and folded, / and folded, like a note in school.
(Muriel Rukeyser)

I was not a little girl when
I finally met up with the Wolf.

That discovery happened as a woman.
By then, I could find my way
to Grandma's place blindfolded,
being her designated caretaker,
the goody-two-shoes girl grown up to be
somebody's Mrs. Right.

Married to a lumberjack,
I was confounded by how small
a place home can be—a kitchen,
a bedroom, a trimmed-lawn front yard
fine enough for neighbors to see.

I pined for skylines
of brick and glass,
conversation deeper than a grocery list,
a map with too many streets
to walk in one day.

The fabulists, so hot for morality,
twisted my tale every which way.
I didn't know then what the Wolf was,
only that he was and I was
supposed to fear him.

Not want to be near him.
That red hood. That snifter of brandy.
Everyone said, *She was asking for trouble.*

Trouble was what I got, and I've got
no regrets except for any hurt I caused.

The moral of my side of the story is this:
you can't find yourself
without first getting lost.

RED RIDING HOOD DREAMS OF
ANOTHER WINTER

There is no snow on the ground.
The woods are filled with the sound
of no sound, not even my own breathing.
It isn't dark. The air is thin with purple
light and the faster I step, the quieter
it gets. Where am I going?

Up ahead I see the trees dwindle
to patchy pine. I'm near the clearing
where the thatched cottage of
my grandma's house should be, but isn't.
I pass the cedar tree into which
I carved my initials when I was only six—

ER (Eve Riding)—and for which
I received the untender kiss of a switch.
Instead of ER there is a fresh wound
in the bark onto which a rainbow-
shaped arc has been cut, a symbol
for what I do not know. I turn

and turn and turn, but cannot see
anyone nearby who could have
made this mark. My finger traces
the shape and feels the dampness
of the wood, as if the tree's rough life
bled when gouged out by the knife.

Am I in bed, is this another dream?
Will I wake to find myself alone?
I think of that poem in which two paths

diverged. Sometimes I wish I had
enough courage to wander off this
well-traveled way, to go where the bold

once headed, out west, to make the best
of a life rife with uncertainty.
Instead of a woodsman's wife,
I'd surely have become a nurse, a healer,
a medicine woman with wolf-skin purse,
or else a teacher who converses

in all the tongues of prairie grasses,
sings the windy song of Palouse.
I know just thinking these
rarified thoughts is unwise.
My kin taught me to mind my elders,
follow their ways. Taught me

that ignoring folk wisdom results
in untold days of tribulation,
like being fooled into seeing
what isn't there—a grandma
in a hairy beast. Ophelia-like
I'd end up carrying wildflower

bouquets in my arms,
instead of the baby I've been
trying to bear for my husband Hunter,
barren this winter,
and last and the one before,
my ovaries sewn with stones.

If this wood world I'm walking in
be a dream, then let it end.
Let me wake to a new dream
of winter, with snow so blue,
so fine, the pines wear capes of it,
outstretched arms like storks' wings.

Let the air ring and ring and ring
with white bells, and let the belly
of every bride rise with new moon
for each wolf who nightly cries
to the punishing sky in brazen voice,
echoing these cold days' unsated hungers.

RED RIDING HOOD WORRYING
OVER GRETEL

That I would be good
even if I gained ten pounds
(Alanis Morissette)

Gretel's always been my best friend but
in her I sense a strength diminished.

When she was young she fought and won
her brother's and her own life, but something's

gone out of her long since.
What to call it—*joie de vivre?*

It's such a shame to watch her now
wither before any mirror.

She shrinks back from the shrunken
image of herself, thinking

she's fat, fat, much too fat.
She's half my weight if that.

She won't eat more than a lettuce leaf
at lunch and gives me enormous grief

if I order a starch,
or much worse, dessert.

"A little chocolate never hurts,"
I say, wiggling a cake-laden fork

beneath her sleek button nose.
She's Twiggy, only trimmer,

and though I try to cheer her,
her mood is always grim.

She's a confirmed bachelorette
who spends nights looking after Hansel

who's never been quite right
since cracking up his motorbike.

I tell her that being single is best,
that married life is far from bliss.

She says it isn't a husband she misses
(and besides, she gets plenty of men

if and when she wants them)
but a mother she wishes for, someone

who'll tell her she's all right no matter what.
I say, "Gretel, you've got me for that,"

but she only shrugs, sighs. "Red," she says,
"it's not enough. It will never be enough."

RED RIDING HOOD TALKS ABOUT
HER MOTHER

In her youth, my mother was corn queen,
a celebrated earth-goddess,
who sent me forth from her womb
in the springtime like an offering.

She made me in her image to grace
the fields with blue-eyed, blonde beauty—a
beautiful smile,
beautiful silence.

But I turned dark—hair and eyes went dark,
dark down there—deep inside,
thoughts wrought with notions to get out
from under Mother's green thumb.

That red-hooded cape set upon me
had dual duties—
to frame the roundness of my face,
(Grandma dubbed me moon lass

with my apple-blush, full cheeks)
and to hide the extra plumpness
of my stomach and hips, for I was not
a wheat-slender slip of a girl.

"Then use those eyes," Mother advised,
"to make men get lost in their dark."
So when I ran off with Hunter,
it was as much to run away from her

as to run with someone else.
It wasn't love or lust,
but something new—
the broken trust of childhood.

Hunter wild, undid my hood, unbuttoned
his shirt, reached under my skirt,
gifted me his version of pomegranate
and I drank it all in, almost willingly.

I was drunk in that truck bed with him,
no thought in my head
for the coming days—
just to escape mother's grasp at last.
How could I know what trap was laid?
From kinder bed to marriage bed,
from garden path and field plow,
to the machinations of wedding vows.

No talk of an education in the city for me,
or my being schooled in skills
higher than the frying pan
and learning to balance a checkbook.

Mother's plan all along was
to keep me tied with knotted strings
to good-housekeeping's apron—
a husband who'd send me home to her

in the spring big with a grandchild.
This dark daughter was supposed to
follow closely Mother's footsteps,
step obediently into her shadow.

RED RIDING HOOD AS WILD CHILD

I used to love to walk
in the woods in the rain.
Mother said it was because
I was a brainless child,
stupid and wild.

She was also fond of asking,
"Were you raised in a barn?"
And I kept wanting to answer, *Yes
Mother, that makes you a cow,*
but I knew to hold my tongue.

In my red cape, I was never cold.
I could go out in any storm
and be completely safe and warm.
Grandma made that cape with love
for sure, but it also seemed

sprinkled with a bit of fairy dust.
It was a magical sheath,
and I was lucky to be entrusted
with its power to make
others adore me when I wore it.

The showers of praise I received
made me feel special as I never had.
The hooded cape suited me, all
the neighbors said, these same folks
who never noticed me before.

But to my mother, I was still an ordinary
brat, the reason for everything wrong

in her life (like father leaving her
for a younger wife) and no coat
was ever going to change that.

Whenever I could arrange to sneak out,
I did—in rain, sleet, snow.
I tried to be discreet, shutting the creaky
back door, quick and crisp.
It was always a risk.

The front door was an impossibility.
Mother was usually passed out
drunk on the couch, but the slightest
rearrangement of a particle of dust,
and she'd be up and ranting.

"Red, get back here!" she'd scream.
"Scrub those pots till you
see God's face in them."
No matter how hard I polished, I never
saw anyone's face in them but my own.

RED RIDING HOOD AT SIXTEEN

I look in the mirror and realize
I will never see a princess or Barbie
in a tiara smiling back.

I have more hips and thighs,
not to mention my dark eyes,
dark hair and too little bosom.

I look into the mirror on the wall
a long while, wishing that frozen pond
would melt, so I could enter

a mermaid kingdom where weight
is the very thing that makes you buoyant.
Or if not that, perhaps some trapped wizard

would show his face and proclaim
I was indeed the fairest of them all,
even if I knew the very idea was insane.

But wouldn't it be something if I could be
the sorceress with the power to set him free.
Tired of staring, of caring, I conclude life

will never be that magical for me—the mirror
gives nothing back I haven't put there.
From the other room, I hear my mother swearing,

"God damn it, Red, get going or you'll be late
for your double-shift at Bluebeard's Café."
So I grab my red apron, spin my hair in a bun

and run out the back door toward the garage.
My beat-up Jeep always stalls twice before it starts,
but I lay my non-glass-slippered feet

to the gas and am at work in the wave of a wand.
In fact, I'm early enough to see Hunter
paying his check, and pinching the cheek of Cindy

going off shift as I am coming on. And though we're
friends, all bets are off when it comes to men.
Though Hunter was no prince, I thought him mine

if I wanted, but apparently I was mistaken.
Hunter is helping Cindy into her sooty coat,
as she jokes, "If not for ashes, my frock

would be threadbare." But Hunter could care
less about the coat, his eyes are boats docked
on Cindy's Barbie-proportioned mammaries.

How am I to compete with a dream girl like that?
She's long and lean with legs the length
of the lunch counter and her teeny feet would

look so sweet in a pair of twinkling glass pumps.
The bell tinkles as she and Hunter go out the door
and Mr. Bluebeard harrumphs. I suspect he has

designs on her, too. I'll try not to dwell
on this the rest of my shift, but I know full well
I'll drive up to lovers' lane at my break

to see if Hunter's pick-up is parked up there,
doing the bump. I've heard Cindy knows
to win a man's heart, you start with his lower organ.

RED RIDING HOOD DIARIES ABOUT LOSING HER VIRGINITY

the great orange bed where we lie
like two frozen paintings in a field of poppies
(Anne Sexton)

Hunter was near,
poised like a hero
in a war
without reason.

We could feel
each other's breathing.
Close by,
an aspen quivered.

Senseless
with animal instinct,
charged blood,
Hunter advanced.

Neither side had a strategy.
Or if we did,
mine was cunning,
his brute force.

He struck. I was
worn down, torn.
The battle ended
with my surrender.

NOTES ABOUT THE HUNTER IN THIS VERSION OF THE FAIRY TALE

I wear green,
not your colors of blood and snow;
(Lisel Mueller)

The Hunter is always the hero,
with his big gun, come to kill the Wolf,
rescue Grandma and the damsel.
Here, Grandma's nearly dead,
and Red is in no lupine distress.

Hunter was a small town boy
raised on a small family farm,
eldest of seven brothers,
all of them keen with tools,
machines and weaponry.

The first time Hunter sees Red,
she's a waitress at Bluebeard's Café
sporting a red apron,
serving cherry cola and strawberry pie—
sweet and sweet.

When they meet for a first date,
what Hunter says he wants—
a warm smile, a hot meal, a goodnight kiss.
But what he actually takes
is something else.

Red may have dreamed of big screen,
fairy tale romance,

but the practical girl her mother
raised her to be knows
Hunter is considered a catch.

Though a dull conversationalist,
he's clever with all things wood,
should be a good provider.
One could say, in his way, he loves her,
and maybe she loves him by default.

Despite Grimm's, their story ends in marriage,
not the ever after bliss fairy tales promise.
So what chance will this lumberjack hero
have up against a cultured Wolf
who knows how to talk and paint and tango?

RED RIDING HOOD DREAMS OF THE
FATHER SHE CAN'T REMEMBER

Desperately close to a coffin of hope
I'd cheat destiny just to be near you
(Anna Nalick)

In the distance, a man whistling.
I'm in unfamiliar woods, shivering.
The surrounding darkness is filled
with the sound of barking hounds.

Dreams of my father
always begin this way.
My mother says he strayed.
He left us before my third birthday

I follow the whistling in my dream,
trusting it will lead to the man's arms,
a father who'll love me, hold me safe
from any harm.

As I get closer, I find the man hunched over
a campfire. He looks up, jaw clenched,
raises something, points it at me—
a sawed-off shotgun.

I run toward him, shouting
"Daddy, please, it's me, your daughter,
Eve. Daddy, please don't."
There's a loud shot.

My belly is wet-hot,
the ground beneath me,
a salt marsh I'm drowning in.
Those hounds bound toward me,

hover over me with their void eyes.
Teeth bared, saliva foaming onto my face.
Then I wake soaked in sweat,
the whistling still there, but faint.

BABA YAGA ADVISES RED RIDING HOOD

> *I was tired of being a woman,*
> *tired of the spoons and the pots,*
> *tired of my mouth and my breasts...*
> (Anne Sexton)

I've pulled the plow
by my teeth, fed souls
of unborn babes on the marrow
of my own bones.

I've called clouds down
from heaven, swallowed the stars
while in my raven guise.
I've charmed snakes,

sung to wolves,
hummed thunder and
spit rain. No one can claim
I've had a dull life.

I'm nobody's wife
and no one's Grandma.
Don't come by my roost
looking for fresh-baked pies

or gooey oat cookies.
I'll give you fire if you bargain
fair and even a lock
of my steely hair,

but you won't get a hug
from me. Don't come whining,

looking for someone to wipe
your snotty nose.

I'd sooner make soup
of your toes. I don't have time
to waste on complainers.
And men, I loved one once.

He was a woodcutting dunce
like yours, looking to marry
his mother in a younger body.
I told him to take a hike.

And when that didn't work,
I cut out his eyes and sent him
toward the pike. That Oedipus has not
been seen or heard from since.

Don't wince, hood girl.
Take my advice,
command mice,
enchant spindles,

put foxes in a trance.
Teach your chicken-legged
house to dance.
A man will just keep you down.

How are you going to patrol
the gateway of the dead
wearing glass slippers
and a ball gown?

Trade in that red cape for
an even redder dress.
Live your story, missy,
your own—not mine.

Never say yes
when you mean no,
and mean no
all of the time.

CHAPTER II
Domesticity

I was not ready for abstraction.
(Emily Carr)

RED RIDING HOOD AT THE ALTAR
WITH HUNTER

What was I hoping for?
The sky to open up,
the glade to fill with light
and God to glide in
to bless what could not
be called a blessing?

Mother, like a second bride
also wearing white, wiping
self-righteous tears.
Hunter was a great catch
everyone said, outrageously
out of my league.

Who was to blame?
Me, for allowing myself
to be pressured
into saying yes
to a man I wasn't sure
I loved. It's a lame excuse.

If Grandma were well enough,
to be present, would she object?
I wanted something
I could not name.
I had not yet dreamt
of the Wolf or the moon.

Since my red cape
was showing wear,
it seemed the right time

to update my wardrobe
with a wedding dress,
trade my hood for a veil.

But a ring of gold
is a flame cooled,
a lock with no key.
I said I do
when I didn't,
I didn't.

RED RIDING HOOD ON DOMESTICITY

It's so difficult to be
a woman with questions
when my mother gave me
all the answers
to everything
except to anything
I wanted to know.

For mother,
wildflowers
were weeds,
the woods
too dark and dense,
the moon
an insufficient bulb.

None of those essential.
A mop and a man
to clean up after,
a frying pan,
a laying hen—
these were supposed to
suffice for any woman.

RED RIDING HOOD ENDS UP WITH HUNTER

I'm pillowed and padded, pale and puffing
lifting household stuffing—
 carpets, dishes
 benches, fishes...
(Lorine Niedecker)

i.
Sand between toes, the silk orange scent
of moonlight at water's edge.
What I wanted then, I did not know,
though I thought I did—
some aspect of adoration
as mother taught me young girls deserve,

a man's eyes caressing my skin,
wine of his lips sweetening bosom.
Hunter looked. He took.
A romantic romp in the woods—fool's quest.
What I didn't know
was everything.

ii.
I was taught that men held the key
for how I should be in the world,
but true love is not as easy to attain
as all the fairy tales maintain.
Who knew how elusive it would be?
It didn't just fade, it failed to appear.

Hunter had blue-steel eyes
precise as his axe blade.

My shoulders shivered in his gaze.
Beneath his bulk came a swift
stalking that ended with my dismay.
Violets and violins, the vision

romance tales touted, vanished,
tenuous as slippers made from glass.
I woke to broad dusty rooms,
my life a square cabin, threshold broken,
midnight, eternal hour of impossibility
in this woman's storybook.

HUNTER INSISTS ON HAVING HIS SAY

They say love conquers all.
You can't start it like a car,
You can't stop it with a gun.
(Warren Zevon)

Listen here, folks,
Red's a good little woman.
Her custards are firm 'nough
and she runs a solid broom.
I ain't got many complaints.

About that cherry cape?
That wasn't her doin'—
her Grammy made it for her
when she turned sweet sixteen.
It's Red's duty to keep to it.

Don't talk trash—Red ain't no
tramp, vamp, or otherwise.
She's as good and true a girl
as ever walked these woods.
Come by our place and see.

She'll be singin'
while she scrubs the tub,
whistlin'
carryin' in the wood,
hummin' over the hot stove.

Red's one happy gal,
I can tell you that,

cause my lovin'
breaks her
into song.

RED RIDING HOOD ON DISCOVERING
HER HUSBAND'S MAGIC MIRROR

Show me a woman who doesn't feel guilty
and I'll show you a man.
(Erica Jong)

Not only does Hunter never admit he's wrong,
he thinks all his bad moods and angry words are
justified, naturally, the other person's—*my*—fault.

No matter how loud he yells or how mean-spirited
his criticisms, he insists he's always right,
never relenting even on a single occasion.

I wonder if this is genetic or environmental—
my father-in-law's universe is similarly disturbed,
and every person in it not him, considered stupid.

How could a man, even in his own mind, never do wrong?
What an incredible burden of conscience must be lifted
with such a gift for magical thinking as this.

The absolute model of perfection and bearer of all
wisdom is the man who always praises my husband
whenever he gazes into his bathroom mirror on the wall.

RED RIDING HOOD DIARIES ABOUT SEX WITH HUSBAND HUNTER

Husband, mad hammer, man of force.
(Anne Sexton)

Is this what passion is?
More like tearing
the knot I tied.
Woods of uncertainty.

Black time.
Subordination.
Silence with no clothes on.

Night's bedrock,
mattress creaking.
Soft moonlight on his cheek,
a disguise.

When you marry an oak,
the body agrees to
lady slippers in shadows.

Conversation dependent on weather,
whether dependent.
The abrupt, unpregnant
pause.

RED RIDING HOOD AT HER JOB AT THE DAYCARE

She learned her hands in a fairy-tale,
And her mouth on a valentine.
(Edna St. Vincent Millay)

I can't help but wonder
what these little girls
will grow up to be,
already toting baby dolls
around at the age of three.

At three, I had my own home-sewn
cloth doll I dragged everywhere until,
to my despair, she fell to irreparable rags.
At five, inspired, I took up chalk
and taught the ants arithmetic.

And here I am, nearing thirty, childless
after trying many times, chalk still in hand,
teaching this formic band
of preschoolers to count
using carrot sticks.

The little boys already shoot
their finger guns,
run, and push and shove.
The little girls hover
over the pretend kitchen stove.

Does this regimented play
come from my subconscious direction

or from their parents' implicit scripts?
The girls sashay hips,
take quiet naps.

The boys bang away
at anything that will cause
caustic noise.
Boys will be boys,
girls will be polite.

When the boys fight or blunder
into bruises, they try to hide
their unmanly tears, appear brave.
They blow and blow their noses,
straining to deny any pain.

The injured girls cry
more freely, but try just as hard
to be brave, so as to save
the teacher from the duress
of managing their distress.

The girls love pretty baby dolls,
tend tenderly to their plastic needs,
feeding, bathing, dressing,
all the things that keep
the focus off themselves.

RED RIDING HOOD WONDERS ABOUT SUPERMAN'S CAPE

Who would Superman be without his cape?
Would he even be able to fly without that
red flag draping behind him?

Could he fight crime in just his suit or pajamas?
Just how much of his power is in the fitted
outfit complete with tights,

big red letter "S" across his chest
to impress upon the bad guys he's
someone they shouldn't mess with?

And if my Grandma had been a sorceress,
what magic spells would she have sewn
into the seams of my superhero cape?

Would I have the ability to bloom
moon flowers during the day?
Could I leap into tall trees in a single bound

so every lost cat could be found?
Could I skip so much faster than a harried hare
I'd arrive anywhere before I even left?

And what colossal crimes could I possibly
fight here in our miniscule metropolis?
Would I help brighten housewives'

gray laundry days by using my x-ray eyes
to sanitize their sheets, giving them whiter whites?
Or perhaps I'd be the emergency

diaper delivery gal or soar in to sweep bats
out of the belfries of panicked padres.
I could catch lollipops before children drop them,

swoop in to snatch Snoopy from the jaws of a coyote
about to make a meal of someone's beloved beagle.
With a stylish swirl of my cape, I'd slide in under

ten-wheelers to rescue squirrels before they go splat,
arrive just in time to wrest hatchlings from
being flattened by a fall from their twiggy nests.

Faster than a speeding bullet, I could arrest every
hunter's kill ratio at zero, granting deer deserved grace.
And when our blundering mayor was facing the
disaster

of having no umbrella in the rain, I could use my
 forceful
lungs to gust the storm clouds to some other domain.
Perhaps Superman himself would want to train me

to be his replacement, so every once in a while
he could take a well-earned capeless vacation.
I'd soar over the forest all the way to real Metropolis,

a female superhero, suited in cape, apron, and boots.
I would just be myself, wouldn't need a secret identity
like their beleaguered, beloved man of steel.

RED RIDING HOOD AT THE
GROCERY STORE

Over at the pyramid display of organic Red Kalle pears,
 I spy
Rapunzel and Cinderella sizing up the shapely, blushing
 wares.

Ever since liberation from her deplorable stepmother's
 tower
by gnawing off her extra-long braid and using it as cord

to lower herself down, Rapunzel's cropped her name to Zel
and worn her hair in a peach fuzz buzz. Cinderella, just
 plain Cindy

when we were growing up, used the extended version of
 her name
as part of her game to win that wealthy prince who came
 to town.

At his fall gala ball, that gown she barely wore with
 plunging neckline
and push-up bra snared his attention. Their fairy tale
 affair ended

in divorce after a scandal about the prince and some
 enchanted sheep.
I heard she got to keep half his assets. Back to Cindy now,
 she and Zel

are living well and very much in love. After they find some
 choice pears,
they notice me, wave hello, then push off toward the aisle
 of fine wines.

CHAPTER III
What Big Teeth

As if my life were shaven,
And fitted to a frame
(Emily Dickinson)

RED RIDING HOOD'S REAL FIRST ENCOUNTER WITH THE WOLF

We meet no Stranger but Ourself
(Emily Dickinson)

After Grandma was diagnosed as terminal,
we sought a second opinion from doctors in the city.
When I took her for some tests, I had a few empty hours
of waiting—a rare thing, with my job at the daycare
and catering to my husband's many whims.

Right across the street stood an art museum—
a structure of steel and glass—to me
more fearsome than any folklore beast.
Yet I felt compelled to go in because it was
the last place anyone would look for me.

As fate would have it, the admittance fee was
more than I could pay, but it was two-for-one day,
and the gentlemen ahead of me was alone, offered.
"Fine sir," I said, "how very kind of you,"
and then he turned—the Wolf—

a dark stranger with eyes like tunnels.
By stranger, I mean like no one I'd ever seen.
His composure was keen, his elegance fierce.
"Not at all, fair one," he said,
and walked away as if walking

were something done with wind and sky
not bones and gravity.
And I didn't know why, but I felt something
within me, unchain—
I went his way.

The room was high-ceilinged everywhere,
thick color forested the walls. Suddenly,
I felt unwell, almost fell upon a bench and sat.
Before me a woman danced.
The placard read, "Salome of the Seven Veils."

I knew the painting was not moving
but the paint whirled around her, dizzy,
whirled around me, and her arms
were serpents drawing me in,
her hips thunderclap, cloudburst,

a soaking rain I had not the sense
to get out of. "Like looking
into a mirror," gentleman Wolf said,
and when he did, at once the rain stopped,
all seven veils dropped.

THE WOLF TELLS RED RIDING HOOD ABOUT THE PAINTING *SALOME OF THE SEVEN VEILS*

"Salome got a bad rap," the Wolf claims.
"It isn't she who wanted the blood
of John the Baptist,
but her mother who put her up
to that severed head business.

Young Salome, barely more
than a veil herself,
had no idea how profound a load
her litheness could be to a man.
She danced on command,

danced as if her flesh was ocean,
as if her bones were tides.
She couldn't observe
the curve of her own form,
a moving continent

any king in order to consider himself
a king, would have to conquer
or die trying. Yet she was a child.
Only her mother's bedtime lips
had kissed her, and the touch

of men—something the kitchen maids
gossiped and giggled over
in their foreign tongue—
another language.
Salome was about to become fluent.

Her mother's husband, a king
of all things great, was not
a man to be denied."
Wolf regards the likeness in oil,
looks back at Red,

offering his arm. "Subterfuge, Miss Hood,"
Wolf proclaims, then whispers something
in her ear. "I'm not an innocent," Red exclaims,
seemingly apropos of nothing. Smiling,
she shyly entwines her arm through his.

WHAT THE WOLF WHISPERED TO RED DURING THEIR FIRST ENCOUNTER

your eyes are like autumn
 after all the leaves
 have come down

RED RIDING HOOD AND THE WOLF
DISCUSS ROTHKO

Time is white
mosquitoes bite
I've spent my life on nothing.
(Lorine Niedecker)

They stand in front of Rothko's painting
White Over Red.

The Wolf says, "What do you see?"
Red looks deeply.

"I see two blocks of color,
one atop the other."

"Yes, but there's more." The Wolf implores her,
"Look again, as if you're leaving."

Red steps back, and as she does,
like Lot's wife, turns.

She sees that the bottom of the canvas burns,
the top becomes a cavity.

Red informs the Wolf,
"Inside desire's many rooms

are many closets,
but all of them are empty."

THE WOLF AND RED RIDING HOOD
CONSIDER THE PAINTING *MAN SHAVING*

"What a gruesome face," declares Red,
regarding the painting of the shaving man

who wears his nose on the side of his head.
"This oil on canvas is chic Picasso-like technique,"

Wolf replies, "with three dimensions flattening into two
in a manner that makes the visage quite skewed."

"Is it meant to be distressing?" Red asks.
"An artist's intention is a tricky thing to guess,"

Wolf says, "It definitely draws the eye and captures
your attention with such intense tints, but there

seems to be a hint of humor about this piece.
The placement of the face turns the viewer

into this vulgar mug's mirror. How does that feel?"
"Like I've been hoodwinked." Red sighs.

The Wolf traces the figure above the frame. "Lines more
cambered than Picasso's, which should lessen the blow."

"All I know is this is not the kind of man I'd want
to marry," Red says aloud, then reconsiders how

she already has. Actually, minus the moustache,
this shaving man is the spitting image of her spouse.

RED RIDING HOOD AND THE WOLF VIEW
CHAGALL'S *LA LECON DE PHILETAS*

Liar's paradox: I am lying to you; this Statement is False.

"This painting is so blue.
Does it make you feel sad too?" Red asks.

"It should be a scene of perfect bliss, man and woman
lying in embrace, a kiss," the Wolf responds.

"But it's as if there's something missing," Red rejoins.
"Their pink bodies," she continues, "seem to glow,

and the man almost appears to be wearing a halo.
It should be serene but isn't. Maybe it would help

if you could tell me what the title means."
"The Lesson of Philetas," the Wolf replies without hesitation,

"refers to the story of an innocent shepherd Daphnis and
an equally innocent shepherdess Chloé who were given

instructions in love by an old pipe-playing teacher named
 Philetas."
"But that Philetas is nowhere in the picture," Red complains.

"Yes, that often happens," the Wolf explains a bit wistfully,
"the students supersede the master and no longer need him."

"Perhaps," Red tries, looking the Wolf directly in the eyes,
"this could be Adam and Eve in paradise,

more in love with each other than they are with God."
"That could be another interpretation of the story,"

Wolf replies, regarding Red with obvious admiration.
Red blushes as if she were a girl with a crush on her
 instructor.

"Interestingly," Wolf says, "there is an actual Philetas of
 antiquity,
a professor of philosophy who is said to have withered

to death over being troubled by the Liar's Paradox."
"The liar's what?" Red inquires.

"It's a logical statement that defies itself," Wolf replies.
"For instance, the statement, 'I am lying' is a prime example.

If I am lying, then the statement must be true, so I am not
 lying.
Another fine case is the contradiction, 'This statement is
 false.'

Do you see what I mean?"
"Yes," Red says, immediately grasping the concept.

She notices her watch, and a bereft expression
comes over her face. "It's time for me to go," she says.

"I don't know how I can ever thank you enough for spending
the morning with me discussing the paintings."

"I'm just sorry it has to end so soon, Miss Red. Perhaps
I'll see you again?" He extends his white-gloved hand.

Red reaches her hand toward his, but the Wolf
brings hers to his lips instead, causing her to blush again.

"I'm afraid I must rush off to fetch my Grandma.
But if you'll just give me your address," Red musters,

I'll send you a check for my share of the admittance fee."
"I wouldn't hear of it," the Wolf says foxily.

"You've paid me double by your company." He bows, frees
Red's hand that she may depart to whatever her own
 paradox.

THE WOLF ENTERS RED RIDING HOOD'S DIARY

I met a worldly Wolf today,
not on the way to Grandma's

but on the city's well-beaten path—
the entrance to the Museum of Art.

He played the part of docent,
made me laugh and feel at ease.

And would you believe Wolf
is an artist himself

looking for a new muse?
He said he noticed me right away

because his favorite color is red.
I thought he was teasing,

but he said I have
a bold, classic form.

I accepted the offer to pose
for him without even asking

if I'd have to
take off my clothes.

THE WOLF REFLECTS ON HIS FIRST MEETING WITH RED RIDING HOOD

it was red, as red as the Swiss flag,
yes, it was red, as red as chicken blood
(Anne Sexton)

She wore that red cape like
a bandage, like bloody bondage.

Who wouldn't want to save her
from the boredom of happily ever after,
which never really was or else the Brothers Grimm
wouldn't have stopped there, would they?

Red was off the path picking flowers, so to speak,
witnessing art up close for the first time.
And what painting should set her to fainting
than the one she most resembled? Salome.

Had Red's mother cunningly showcased
this daughter's wares for her own gain?
I could only guess, yes, she had, for Red's eyes
were fair sorrows, untried amber.

I smelled trepidation, so I vowed
I'd make a feast of her salvation.

RED RIDING HOOD DREAMS OF THE WOLF

The Wolf is lying in Grandma's bed,
the room filled with his lupine scent.

I find myself next to him, naked,
my belly strangely swelled as if with child.

I notice blood welling up from
the Wolf's abdomen, a red spouting fountain.

"Please drink," the Wolf pleads.
And so I sip from that cascade,

salt and sweet, hot and thick.
I sip and sip. I lick him clean

of blood until he sings out a howl.
Then in me, stirs a loud reprise,

rises from deep inside. I howl
myself awake. I bay into the new day.

CHAPTER IV
The Plot Quickens

*the spirit what the
soul has eyes for*
(Diane di Prima)

RED RIDING HOOD MEETS THE WOLF A SECOND TIME

And I'd like to be a bad woman, too,
And wear the brave stocking of night-black lace
(Gwendolyn Brooks)

It was not at my Grandma's place, as those
brothers like to say, but at a poker game
I came to meet the Wolf for a second time.

Not dark woods, but a crime-free suburb.
I didn't care to go, but Hunter insisted,
said other wives would be there too.

He had me bake a special rhubarb pie
laced with red-label gin just to be sure
I'd make a good impression.

I was astounded when the Wolf came in,
had no idea he and Hunter were acquainted.
Wolf introduced himself with tact, gave nothing away.

Then we all sat down to play.
The opening bid was Jacks or better.
Wolf looking very serious, rolled up his sleeves

to reveal silken-furred forearms, manly phalli.
Though I was distracted, I played to win.
Nothing more was exchanged

between us that evening than
pleasantries, some pocket change.
Nothing more, until I rushed to the door

as he was leaving, slipped him a note—
on the back of a deuce I wrote Grandma's address
and the time I'd be there the next day.

I don't know what I was thinking, or if I was.
And I'd like to tell you lust didn't hold me
in its clutches, but that wouldn't be the entire truth.

AFTER THEIR SECOND MEETING, THE WOLF REFLECTS ON RED RIDING HOOD'S CAPE

Her red cape makes me think of a battle flag
raised in ignorant pride by soldiers too young
to know what dying looks like.

That same flag later stains with
the blood of their innocence.
Poor Red, a young drafted soldier shipped

from one encampment to another,
mother's house to husband's,
the life she'd been in training for

and will die of, unless she finds her way off
the narrow path of needles
to where the wood grows deep with shadows,

where much is possible, even that darkest
kingdom of all—the one bedtime stories
trick you into avoiding: sin, aka self-knowledge.

Fairy tales are perverse portents.
History bears this out.
Blind obedience destroys the obedient.

RED RIDING HOOD AND THE WOLF
BEFORE IT IS TOO LATE

When you came, you were like red wine and honey,
And the taste of you burnt my mouth with its sweetness.
(Amy Lowell)

As if they are at a cocktail party,
and what is required of them
is merely blasé conversation,
Wolf fills both their glasses
with Grandma's special Port.

Red gives a nervous laugh.
Wolf raises his glass, asks,
"Surely Red is only for your
trademark cape, so what
is your given name?"

"It's Eve," she says, "though
no one's used it since
I started wearing that coat,
and the weird thing is, my husband
Hunter's first name is actually Adam."

How ironic, Wolf thinks,
but does not say.
Instead he coughs, offers,
"My real name is Frank
but no one ever calls me that."

"Don't say never." Red laughs.
"Frank," she says aloud,
"I like it, Frank," she repeats,
tasting his name on her tongue
before tasting the rest.

WHAT RED RIDING HOOD REALIZES

When what you don't want
and what you do
coincide—

the Wolf has entered you.

RED RIDING HOOD ON SEDUCTION

You will not see / that desire begets
love, / until it all flames
into one concise / and metallic blaze.
(H.D.)

What did he think,
I would be ignited by the twin torches
his eyes became, those midnight flames?

Or that his knowledge of Kandinsky
would have me on my knees
begging to unbuckle deeper knowledge?

I can't say.
He kept it to himself, so damned polite.
But if he did, he was right.

Oh, my mother warned me
about wolves—
their scented necks, their feral ways.

But she said nothing
about the cultured wolves,
the white glove kind.

That was my undoing.
I fell for his manners,
more than a simple please and thank you—

something akin to grace.
Yes, I call it that,
the patience it takes

to go at another's awkward pace,
the lust to listen to another's talk
the way fire listens to the wood.

Oh, and my need to be heard,
who knew (not me) its impacted depths?
He unearthed from me desire's Paleolithic oil

and a spark of laughter, the two, fuel
enough to keep my body's lantern lit
for what could easily be ever after.

THE WOLF THE MORNING AFTER

And your eyes and the moon swept the valley.
(Carl Sandburg)

Thin light of dawn,
Red's tangled form
in the bed like a stain,
like spilt rosé.

What have I done?
Red was no Mary.
She had lain with Hunter,
perhaps many hunters.

Yet, there must be something
that restores virginity
in a woman
who has never been

properly touched.
Restores,
then breaks it again
with tenderness.

And who is more tender than a wolf
with an inexperienced cub?
What began as lust,
a gnawing in the gut,

maybe just my lupine libido,
is something else now.
I'll say it—what I dread most—
rapturous love.

I've been captured.
I feel unwell, like someone's
sewn stones in my belly.
I'm getting the hell out of here.

RED CHIDES HERSELF UPON WAKING IN
GRANDMA'S BED ALONE

After lying down with the Wolf
I woke to smoke
and mirrors—

the smoke, my breath on the window,
the night-turned glass, a mirror.
The outside world

an unseeable place,
all that's visible—my face
and what I have done.

Was it that it happened so fast
I couldn't be considerate
of the relationship I'd promised

would be my last, my only?
It's true, I wasn't experienced.
Hansel was the one other boy

I dated—but that was ill-fated.
He and I were waiting
until we were older

for any serious lovemaking.
No one could have known
that he would be thrown

from his motorcycle and lose
most of his mental functioning.
So heartrending, Hansel the sweet boy

gifted me endless confections,
though he ate most of them himself.
Now, I bring bonbons when I visit him,

and he barely acknowledges who I am
before tearing through the box.
Lack of experience is no excuse

for falling prey to a sexy Wolf.
What can I say for myself?
I'm a worthless adulteress,

a beast mistress,
the worst woman ever
to cruise these woods.

A curse to my husband,
I'm no good,
no good, no good.

CHAPTER V

Myths

We think the fire eats the wood.
We are wrong. The wood reaches
out to the flame.
(Jack Gilbert)

THE WOLF ADMITS TO CROSS-DRESSING

We wore each other like skin,
like dressing in one another's clothes.

We spent the rest of our time dreaming
in museums, laughing over cappuccinos.

We were so close, that between us
there wasn't enough room for secrets.

RED RIDING HOOD AFTER A SECOND TRYST

I close my eyes and suck you in like a fire.
(Anne Sexton)

I startle awake.
Where am I,
naked,
alone in a strange bed?

No, I'm at Grandma's again.
In the still-pink light,
I take in
my surroundings—

brass footboard,
lacquered hope chest,
oak bureau,
blue-striped slipper chair

out of which a pair of
luminous eyes stare at me.
Eyes that baptized me
the entire night,

eyes that required flesh
as proof of faith.
I'm rapturous.
I can hardly bear this bliss,

so aware am I of my blood
coursing new pathways
beneath my skin,
to the fleet-footed

beating of my heart.
I'm all heat
with Wolf's body so near,
his beast breath on my feet.

RED RIDING HOOD ASKS HER
DIARY ABOUT SIN

Yet to sing love,
love must first shatter us.
(H.D.)

Was it the fecundity of the museum
that made the Wolf seem an answer?
Being surrounded by art,
the erotic hand of dark

in the paintings and sculptures
that made me see my own dark?
Was my marriage an ark I used
to escape my inner self,

innocence, a mask I donned like
my red cape?
Or did I know somewhere deep,
I couldn't keep to the path I was on,

having never given my own desires
any expression?
I felt such exhilaration at being taken
seriously by one who could say so much

about so much, the Wolf such a wise beast,
a fountain of information.
Is that why I had to touch him?
Was my carnal feast

an attempt to take him inside me the way
that other Eve sinned, with the help of the snake,

swallowing the apple for knowledge sake?
Or maybe, my moral core was always rotten.

I'd never before been so besotted with any male.
I'm not making excuses.
It was wrong—what I did was wrong.
Not because I belonged to my husband,

but because I took a vow
and however mindlessly I did so,
I should have kept it sacred,
not callously broken it.

Is there ever truly absolution?
Was Eve saddled with guilt
the rest of her days
for wanton disregard of God?

Is this the way of the feminine,
a woman having to abort
her traditional upbringing
in order to conceive her true nature?

RED RIDING HOOD CONFIDES IN GRANDMA

My Grandma, feeling better, is at the stove
stirring her signature lamb ragout.

I want to tell her everything,
but my mouth feels full of glue.

"Grandma," I finally say, "I feel like I'll burst
if I don't confess to you."

"You can tell me anything, dear one.
You've nothing to fear."

"I don't want you to think less of me
but I've broken my wedding vows.

I've cheated on Hunter with the Wolf."
Grandma transfers the ragout from stewpot

to brimming bowl, holds it out
to me to make me take it from her.

She looks me straight in the eyes
as calmly as if she hasn't heard.

"Dearest, Red," she says, "this is what I learned—
just be careful with what you've got.

It's very full, it's very hot,
and if you spill a drop, you'll get burned."

RED RIDING HOOD DISPELS THE MYTH OF WHAT BIG TEETH

So, you want to know where that whole
ludicrous business about the Wolf
in Grandma's nightclothes comes from?

It began as a dream Grandma had long ago.

Grandma told this dream to my mother
and saying anything to that woman is akin to
broadcasting it across the universe.

Grandma related the dream to me this way:

There was a knock at my door,
and I found myself fallen to the floor,
so I called out, "Come in, I need your help."

And when the door opened, I saw it was a Wolf
wearing a magnificent red cape.

"Oh, Wolf," I said, "I feel I've died and gone
to heaven seeing a thing as lovely as your cape."

And then the Wolf came over, lifted me up,
and said, "Dear Lady, have you forgotten?
It was you who sewed this cloak for me."

I was in his arms and we began to dance.

He said, "Oh, Grandma, what big eyes you have."

And I smiled and replied, "The better to see you
waltz, Wolf dear."

At that he smiled, and I said, "Oh, what big teeth
you have." He replied, "The better to eat
your cherry pie with."

Then we both laughed and kept on waltzing.

That morning, I awoke to a pounding at my door.
It was your future husband, Hunter,
saying he heard an awful racket
coming from inside my cabin.

I assured him it was nothing
out of the ordinary, just my snoring.

Grandma sewed the cape she'd seen in her dream
and gifted it to me.

That myth of terrible violence folklorists claim
comes from rumor, hearsay, slurred prattle—
the very same stuff fairy tales are made of.

THE WOLF SHATTERS A MYTH OR TWO HIMSELF

In her bottled up is a woman peppery as curry,
a yam of a woman of butter and brass,
compounded of acid and sweet like a pineapple
(Marge Piercy)

First, let me say Miss Hood was not
beautiful in a fairy tale way—
not fair-haired with Hollywood-
sized bosom, neon teeth,
skin so taut over her bones

you expect a drum sound
if you lightly tap her abdomen.
She was not one of those flashy
maidens who stash
a flirting fan up their sleeves.

Neither could you conceive her
beautiful in a Victorian novel way—
slight, frail bodied, a hovel of a girl
pale as paper, with veins showing
through like blue ink waiting

to be told into story
(though hers was, I suppose).
If not for that fluorescent cape
you could walk right by her a hundred
times, never take notice of her.

You might dub her homey,
of peasant stock, a solid girl.
the typical woman of her age,

medium height and weight,
brown hair and eyes.

Dissatisfied? Disenchanted?
Need all your heroines to be
center-fold ready?
Then stop reading now.
But, if you care to know how

beauty is best defined, read on.
It's not an innocence of guise,
though that was there, sadness, too.
Red's true beauty is in the way
she looks at you,

an earnest interest
that sees deep into your soul.
Her beauty's in how her lips
are given to parting into such
a sincere smile, her face becomes

a portrait of compassion.
And Red's humility gives her the ability
to laugh at herself, a lovely trait.
Now, if this is not your idea
of ideal pulchritude, perhaps

real life is not the place for you.
Pack up your things and install yourself
on Perrault's crumbling porch.
Then huff and puff and blow
'til you bluster your way in.

GRETEL ADVISES RED RIDING HOOD

It didn't matter what my friends would say
I was gonna see you anyway
I just wanted to see you so bad
(Lucinda Williams)

Red, you're like a sister. Though I'm no
expert on sex, despite my conquest

of every one of the seven dwarfs
before sleazy Snow White

moved in on them
(and Sneezy still says he prefers me).

But the way I see it, it's just honey.
Better to be buzzed by more bees

than give up all your pollen
to one hungry fellow

no matter how furry
or feral he may be.

Besides, you've already
got that wooden drone at home,

do you really want to hitch yourself
to an artsy alternate?

Red, spread your clover all over
as I do. These woods are busy with lovers.

HUNTER WONDERS WHERE HIS WIFE GOES AFTER WORK

Her cover story begins to wear thin.
Red's been telling Hunter she takes care

of sweet dull Hansel while his sister Gretel
gets treatment at Mother Goose's anorexia clinic.

But Hunter's becoming suspicious,
Nobody's that much of a saint, he thinks.

She must go out for drinks
with the other daycare gals.

When she walks into the same beer lair as me,
I'll have to drag her home by her hair.

CHAPTER VI

If the S(k)in Fits

I want to be inside your darkest everything.

(Frida Kahlo)

RED RIDING HOOD FOR REAL

Even bad wolves can be good.
(Ronald Blackwell)

Now you know the story
as it really was.

Not spring tread upon
by death's cold breath.

Not Lucifer in the guise
of Wolf's clothing.

Not innocence lost
or a punished child.

Here is Red.
There is the bed.

The Wolf can howl
all he likes.

It's only a request.
The rest

is a woman
making up her own mind.

RED RIDING HOOD AFTER MEETING THE WOLF A THIRD TIME

The heavy sensual shoulders, the thighs, the
blood-born flesh and earth turning into color
(Muriel Rukeyser)

The sky has already forgiven
last night's rain,
trees shaking their damp
green limbs in the breeze.

The stone path away from Grandma's
smiles along all its ancient cracks
as I hurry back toward home.
In the distance, tractor trailers hum

where traffic lights thrum through
all their lollipop colors—
trip yellow, red, green for go, go, go.
Oh bright lane, oh new day.

RED RIDING HOOD ON GENTRIFICATION

I live in a tract home,
"five over four and a door"
in realtor talk, where the only
aesthetic is sameness.

Even in our minute hamlet
traffic can be a bear,
so I walk everywhere
I can and welcome

the change of scenery
going to Grandma's means.
She lives in the old part of town
that's starting to undergo

the gentrification process
that turns old into shabby chic,
and unaffordable for the artists
who moved in, brought beauty

back to the neighborhood.
It just so happens
the Wolf lives across the lane
from Grandma's, a painter

who favors red (lucky for me).
Wolf is not a threat
to Grandma or any young girls.
If he poses any danger whatsoever,

it's to our social order
that demands conformity.
Being a creative spirit,
the Wolf excels at one thing

especially—individuality.
In his paintings trees
are red, clouds red, skies
red, people's eyes red,

red beds, red peas, red
coffee and bright red seas,
all red except for me—me
he paints wholly white.

THE MOMENT RED KNEW

Always the beautiful answer who asks
a more beautiful question.
(E. E. Cummings)

If you had asked me that first morning
if I was happy,
I would have said,

sure, of course, why not?
Hunter and I have a quaint place,
no luck getting pregnant

but I get my fill of kids
at the daycare, don't I?
What did I know?

I, who had never neared
life's flame.
I'd never known

my mind to wander
past wondering about
what to cook for supper.

I had no idea there exists an entire
menu of desire.
Some would blame

biology, pheromones, chemistry.
Yes, the Wolf's scent drove me wild
but it went way beyond.

I found a poetry
alive in my own hands.
I could press my fingers

to his breast bone and make a song
the rest of him would harmonize.
My body was lyric and lyre.

I loved the fire.
I learned a not so simple truth—
skin is more than skin

and sin has wings
the angels themselves
must envy.

RED RIDING HOOD'S DIARY FRAGMENT
FROM THE FIREPLACE

Who is she, this once apple-faced girl,
who's fallen from grace?

I said three *Hail Marys*,
the sins of the father.

I asked for forgiveness.
But what does forgiveness ask of me?

THE WOLF ADMITS HIS WEAKNESS

i like my body when it is with your body. It is so quite
* new a thing.*
Muscles better and nerves more.
(E. E. Cummings)

Chianti afternoons,
the mozzarella moon,
her pomegranate lips.
Who could resist—could you?

A woman in red who
scarcely knew her own beauty—
or should I say—power?
Even an angel would fall.

Some think I was the snake
that spoiled all her innocence.
But sin is a completely
unoriginal act,

and love is a contract that
requires more creativity
than most can sustain,
even a tamed beast.

RED RIDING HOOD TAKES TO THE EASEL

Hollowed out, clay makes a pot.
Where the pot's not is where it's useful.
(*Tao Te Ching*, translated by Ursula Le Guin)

Nowadays, Wolf and I paint side by side
in his cozy studio,
out on the bluff.

With my new ink and pen set
I'm learning unintention,
negative space and chiaroscuro.

"Don't erase anything," Wolf says.
"Let your images chase you,
let the canvas show you what it wants."

It's curious my art looks nothing like
the world I see, more like the daunting
roiling that's always haunted me,

that indefinable anxiety,
that achy itch
my husband always told

me was just hormones,
right before calling me
a crampy bitch.

Wolf jokes I'm the secret spawn of
Jackson Pollack
and Frida Kahlo.

But Kahlo's womb
remained as hollow
as mine.

All of this is so foreign,
this feeling my way through,
all intuition,

yet it feels thoroughly true.
Wolf tells me all about the great
movements in art,

carts me to museums and galleries.
Soon Wolf will have me
work with clay.

He says it's more than molding
and throwing bowls,
more like play.

He says clay work,
like all art,
is about centering,

about allowing
the moment of creation
to enter you.

THE WOLF RELATES THE
TALE OF PHILOMEL

They were still in bed,
Red nude and the Wolf draped
in a dropcloth, when they
heard the dusk bird's lament.

"Unrelentingly sad, sweet Philomel,"
the Wolf said, rising and going
over to open the window to let
more of her song into the room.

"Do you mean that nightingale?"
Red inquired. "Why call it Philomel?"
The Wolf took up his stool by the easel,
"Then you haven't heard the tale?"

Red shook her head.
"Well, it isn't pretty, pretty one,
but I will tell it nonetheless.
The Greeks have a fondness

for origins, describing how things
come to be what they are.
Philomela and Procne were the lovely
daughters of King Pandion of Athens.

Procne was married to King Tereus of Thrace
and bore him a son, Itys. But Tereus lusted
after Procne's sister too and soon tricked her,
took her into the dark woods where he

raped her, cut out her tongue then
imprisoned her so she could not tell
anyone of his crime. But in time,
she was freed, and she began to weave

a tapestry. So great was her artistry
that she wove the tale of her woe
so clearly Procne understood what harm
had come to her sister and by whom.

To get revenge, Procne killed their son,
cooked him, and fed him to Tereus for supper.
When Tereus discovered what she'd done,
he took up his axe, but before he could attack

the sisters, the gods turned all three into birds:
Tereus into a hawk, Procne into a swallow,
and the nightingale was what became of Philomela."
"But what about Itys?" Red asked.

"He was eaten, nothing more."
"I would have thought he'd break open
Tereus' stomach and emerge as wolf,"
Red said, going over to stroke

her lover's face. "There is hope
in that story," she continued, "isn't there?
The wounded woman without a voice
speaking through her art with thread."

"You are so clever, Red," said the Wolf,
stroking her face as well. "Art tells the truth
which is why the artist is always feared
more than she's ever revered."

"Darling," Red said, "everyone's afraid
of you, afraid of the big bad wolf
because they never know what deeds
a creature so true to himself is capable of."

RED RIDING HOOD PAINTS WHILE THE WOLF SLEEPS

Shot with innumerable hues.
(Sappho, Mary Barnard translation)

The way he's curled and faintly snoring
makes him seem more like an adorable cub
than a big bad Wolf.

I try not to make any noise
so as not to wake him as I move
to the easel,

take up a brush and start to paint
on the stretched canvas onto which
he's sketched

an image of me, lying naked in bed.
I start at the head and slowly
dot my hair with cobalt sky

with low lying Payne's gray clouds,
the Latin name for which he taught
me is nimbostratus.

For my eyes, I choose Hansa yellow opaque
to suggest willow leaves late, late spring
just before they weep.

On the flesh of my face and neck I streak
cadmium, cinnabar, crimson, and position
a burnt sienna sunrise over my right cheek.

My breasts receive ultramarine violet,
my chest wall a chromium green,
my ribs the manganese of rivers and streams.

From my navel to pubis, I spread burnt umber,
Van Dyke brown, Venetian red, colors of
topsoil, humus, worm-deep earth.

My thighs to the curving length of my legs,
become a sea of Phthalo blue, cerulean, viridian,
every shade from calm to storm.

The bed itself, I swathe in carbon black, daub in
the silvery stars. I finish with ochre for the moon
lying on his back, snoozing next to the woman.

Setting aside the paintbrush, I step back to admire
how the renewed nude seems to
spring forth from the canvas, singing.

RED RIDING HOOD GOES COAT SHOPPING

I can't say when it'll be complete, only that I'll not
 cease until
it's longer, rounder, tighter...and with a little more red.
(Susan Mrosek)

It was time for a change, I thought,
the old cape starting to fray,
seemed a bit ratty, faded.

Being a practical girl, all I'd ever worn
were tee shirts, jeans, cardigans,
bargains from the local five and dime.

I hardly knew where to go for something
finer, so I consulted my aunt Goldie.
Goldie was a picky sort who never

bought until something was just right.
She advised I try the Palace Mall.
So I ventured there by way of Greyhound

coach, thinking myself gauche, not unlike
Cinderella fretting over an outfit for the ball.
I couldn't believe all the shops at the mall,

each one fancier than the one next door,
with crystal chandeliers and marble floors.
I stopped in a place called Three Bear's

Boutique where there were racks
and racks of women's wear
and brooding mannequins as trim and grim

as my painfully thin friend Gretel.
"May I help you, Madame," said an equally
svelte man who looked part goat. He snuck up

from behind a tree of sequined belts.
"I'm in the market for a new coat," I said,
"something simple, please."

"Understated, yes, I've just the one
for you, that will hide all that flesh,
give the illusion you're a size two,

zero is just out of the question."
He brought me a black coat most
austere, with buttons that were clear.

"I think you'll find this is your size
and style," he sneered. "I'll try it," I said,
"in the dressing room."

He pointed the way as if tossing a stick
to a dog, said, "Make it quick,
Madam, I'm almost on lunch."

"Thanks a bunch, but I can take it
from here," I replied in an even tone.
He harrumphed noticeably,

then disappeared. Once inside
the dressing stall, I set my cape aside
on the bench, regarded the urn-like

shape of me in the full length mirror.
Is this what the Wolf admires when he
looks at me? He calls me lovely

in a Rubenesque sense. At first,
I thought him just another cad
casting a line to lure me into his pad.

And of course, that's what happened,
but ever since, he's been so earnest.
Wolf is much more dear than he would ever

want known. His reputation is that of
a creature as wild as his creations.
But he's very gentle and in his arms

I've found a home, unlike any I've ever known.
Unconditional acceptance,
no admonishments, no complaints.

Is this how love is supposed to be?
I didn't know. I donned the black coat, looked
at the face that looked back at me.

Above the double-breasted, worsted
wool was a woman calm and rested,
neither young nor old,

neither conservative nor bold.
I took off the coat and re-donned
my cape. The woman smiling back

remained unchanged—the face of
a woman at ease with herself.
What a surprise to see such composure

in her eyes. And so I left that grave
coat behind, bought instead a grand
chocolate cone at the food court,

then headed home again
on the Greyhound bus,
draping my old cape more rakishly.

CHAPTER VII
Sticks & Stones

And suddenly we see that love costs
all we are and will ever be.
Yet it is only love which sets us free.
(Maya Angelou)

"RED RIDING HOOD KISSES, TELLS ALL"

The tall-lettered headline in our town rag
was all conjecture.

> I never told a thing back then,
> not to anyone but Grandma.

> And my best friend Gretel nagged me about
> where I disappeared to late afternoons.

Maybe my mother tipped off the reporters
because she was so disappointed in her daughter.

Or it was my outraged husband Hunter's revenge—
trying to shame me for being an unfaithful wife.

The media tells it as if I had no regard for my loved ones,
flaunted the affair.

> I was dismayed by what I'd done,
> wracked with guilt.

That I had given myself to the Wolf
rocked me to my core, tore me apart, and yet—

> it primed me for becoming
> what I previously was not—

> an independent woman
> of independent thoughts.

RED RIDING HOOD ON BEING TALKED ABOUT

If you must gossip,
say lust is the unruly disease
that truly, fully woke her to life.

Say she never had a chance
to season her own thoughts
away from the bland stove.

Don't say she was caught in the Wolf's trap.
Say she was selfish—I can live with that.
Say, finally, she thought of herself.

STICKS & STONES

Bitch
Witch
Wench
Whore
Cunt
Slut
Tart
Tramp
Vamp
Vixen
Minx
Nympho
Ho
Hoochie mama
Bimbo
Jezebel
Sorceress
Strumpet
Slattern
Sleaze
Slag
Skank
Sexpot
Pig
Prostitute
Hood rat
Hooker
Harlot
Hussy
Loose

Floozy
Fallen
Free

Finally

free

FOUND OUT

I hardly taste you at all for I know your savour,
But I am completely nourished.
(Amy Lowell)

It was mostly innocent by then,
our excursion to the city
to see the many galleries,
the great library
sentinelled by lions,

the stained glass panes
of crumbling old churches.
We walked arm in arm
lost in art and talk of art,
with no thought to who

might see us and report.
We were a pair as excited
by ideas as we had been
by the sin of our flesh
previous afternoons.

And we knew—
or at least I did—
that the flesh inferno
had given way to
a more steady flame,

the sane spark mentoring is.
Already, I could feel
the bliss of something inside
long meant for kindling
finally kissed by fire's tongue.

I crackled with the prospect of
becoming known as someone
more than the woman
who wore a red cape.

Would I paint abstracts like Wolf
or compose personal tracts
like Thoreau?
I didn't know, but understood
my former chaste self-restraint,

my polite apology to society
for being female was over.
I'd become author of some new
inscrutable ever after.
Hellfire was to come our way

because someone
Mother knew had seen
the Wolf and I that day.
My husband Hunter would be
hurt, shamed.

My mother would be outraged,
casting blame.
My Grandma, very ill by then,
could only speak my name,
smile and squeeze my hand.

RED RIDING HOOD'S APOLOGY

We'd hit bottom.
I thought it was my fault.
And in a way I guess it was.
(Ben Folds)

I'm sorry I lied. I should have
tried to tell you. You never would
have had to find out from gossip
rather than from my own lips.

I know it's cliché to say
it had nothing to do with you
but that's really true.
It was something missing in me

and I wish I'd discovered this
before I ruined our life together,
before I became your wife.
I was sleepwalking through

my days without a clue
that I was giving you less
than you deserve.
I know forgiveness

is out of the question.
But please let's leave
the Wolf out of this.
I'm ready to move from our home,

go on with my life on my own.
If I could atone, Hunter, I would.
My sorrow for hurting you
weighs on me like stone.

HUNTER'S MOMENT OF CLARITY

> *Take everything that we have. Take it and burn it*
> > *to the ground.*
> *Some things were never meant to last.*
> (John Hiatt)

We should've been considerin'
calling it quits anyway.
Who were we tryin' to fool?

Hey, I wanted to believe we
were livin' the American dream—
young marrieds with enough green

for a sweet little place of our own.
I'm one of seven brothers and
if you'd asked me my druthers

before you whored around with
that stinkin' Wolf, I would have said,
sure I want to have seven youngin's.

Not that I'm not stung about
what you've done,
but you set me thinkin'

maybe I'm selling myself short
here too, casting my lot with you
and doing the same as others do.

I was madder than a beaver
got his tail whacked off
by the stray stroke of an axe.

Even thought about smackin'
the crap out of that Wolf.
But after drinkin' a few beers

I'm calm as a queer in a brothel.
Maybe it's all for the best.
I'm gonna head out west

see what kind of things
a real man can do,
if he puts his mind to it.

Heck, maybe I'll even
check out Hollywood,
see if they need a new hunk.

You want our junk, the house,
you keep 'em, payments too,
can't help you there.

Maybe stayin' true is rare, Red.
I guess one of us wasn't gonna
meet temptation and say

more than how-da-ya-do.
Wish it wasn't you first.
Kind of makes us both look

worse than we are—
you a tramp and me damn useless.
Remember before we was us,

you were a waitress,
me new to tracking and lumber jackin'.
We rocked the heck out

of my flatbed Dodge Ram.
Maybe if you'd been pushing
a pram by now you wouldn't

have gone rushing into some
stranger's bed like a man—thinking
with what you got between your legs.

I'll forget all about you, Red.
Your mamma though,
shame to lose her too.

She's one gal knows her way
around the kitchen—her fine cookin's
stuck to these ribs of mine.

RED RIDING HOOD'S MOTHER BERATES HER

but, oh, my friends in the end
you will dance the fire dance in iron shoes
(Anne Sexton)

You brought scandal
to our clan, a long line
of fine wood folk.

Never could I have
imagined my darling
cherub would climb

into bed with a wolf.
A wolf!
Didn't I warn you enough

times those beasts are not like us,
tell you how they're inferior?
Didn't you know this would

reflect on me as a mother?
Did you bother to think
at all, or was a little

wink and wolf whistle
all it took to get you
to lift your skirt?

Do you have any idea
the hurt you've inflicted
on your husband Hunter?

I worked so hard to get
that man into our family.
Months

of my rabbit stews,
meatloaves, and pot roasts
just to persuade him

to wed you.
Such a prince of a man.
If I was ten years younger

it's a cinch I'd have won him
myself and fed his hunger
in bed a lot better

than he's told me you can do.
He says you're a real prude
in that department.

Well the harm's been done,
so why stick around?
Leave town.

Maybe in ten years this'll blow
over and nobody will know you
when you come back.

Better yet, don't come back.
I won't miss you,
you rotten witch.

You're a selfish bitch to rob
your poor old mother of
the chance at grandbabies.

I hope you're ashamed
and your bad name
follows wherever you go.

It's monstrous what you've done.
Don't flaunt it
in everyone's faces like

the scarlet harlot you've become.
Your no-good father's
to blame for this,

running out on us
all those years ago.
Good riddance to you both.

And Red,
for pity's sake, get rid of
that damned devil-cape.

WHAT THE WOLF TOLD A BARTENDER
ABOUT RED RIDING HOOD

I was alright 'til I fell in love with you.
(Bob Dylan)

I wasn't out to devour her.
Red was the kind of woman
who couldn't find herself
in a mirror.

How could I foresee
she'd end up consuming me.
Now, I can't see myself
without her.

CHAPTER VIII

A New Red

*You can only go halfway
into the darkest forest, then you are
coming out the other side.*

(Chinese Proverb)

RED RIDING HOOD CONQUERS
ANOTHER MYTH

It wasn't the Wolf that seemed
to have such big teeth—
it was the hunger.

Hunger so massive
it masticated all dreams
gnawed on the walls of my house.

Hunger so enormous
it was the core of us—
Grandma, Mother, me.

We inherited the broom,
passed it one generation to another—
to sweep, sweep, sweep

the crumbs and dust,
the leavings of others.
We were told to sweep and be grateful.

Be grateful for kitchen appliances,
for a reliable man in the bedroom,
for children's needs

we could tend,
for the sick and infirm we could
befriend, bring wine and cake.

But could we dance in the rain
splatter paint on a canvas,
without being called selfish witch or insane?

Could we howl at the glassine moon?
No, none of these were permissible.
Egg droppers, we become our own rags.

When I staggered upon a wolf animus
inside me, I embraced my wildness,
went deeper into my own dark side.

I can be sweeper no more, weeper no more.
Let the broom loom over me no more.
I claim myself as moon.

RED RIDING HOOD MAKES LOVE
TO THE CANVAS

There is no savor more sweet, more salt than to be glad to
be what, woman, and who, myself, I am...
(Denise Levertov)

I was married to grief a long time.
Now I'm divorced
and desire the canvas more
than any flesh.

The heft of my hand
moving against
the lush blankness
whose silence is

not ignorance, not indifference,
but urgency for my touch.
The swirling colors blend, extend
wider than perspiring thighs.

My hesitant, slow hand,
my frenzied pulsing hand,
my tensing held-back hand,
my climaxing thrust.

Erotic rush,
brush
shuddering
midair.

RED RIDING HOOD'S SHOCKING DIARY ENTRY

At first,
it grew in me
a new metaphor—

the poetry of it,
and not
the reality.

THE WOLF GUESSES
RED RIDING HOOD'S NEWS

Red lazes in the nude
on the Wolf's bed.
He stands at the easel sketching
the soft, pleasing lines
of her face. In her head,

she's pacing, trying to find a way
to say what's been on her mind
since her home tester
showed blue positive, confirming
what she already knew.

After the many trials of negatives
with Hunter, she was in denial
about her own fertility,
wrongly placing all the blame on herself.
It must have been Hunter's problem

all along and she simply believed him.
Red wonders if the Wolf is aware
of her belly's slight thickening,
or the light flush of her cheeks.
Her eyes turn up to meet his, and as if

he's read her thoughts, he speaks,
"Red, will we be celebrating soon?
Are you with child?"
Tears drop from her eyes. She replies
by nodding.

"I know it's ours. I'm over the moon,"
he says, dropping the coal he's been
sketching with, rushing over to embrace her.
"What should we do?" Red whispers
in Wolf's ear.

He's busy covering her teary face
with kisses. He whirls her up
from the bed into a waltz.
"Love him or her of course,"
he says aloud,

"as I love you," he continues,
"and love anything of you
and our union."
"Me too,"
Red manages.

Suddenly, her grief and worry
peel away like the molting
of a stiff second skin,
a weighty ghost twin.
Relief pulses

through her, composure
comes over her, then elation.
She leans into her lover's chest, waltzing
like someone who's discovered waltzing
is precisely what legs are for.

RED RIDING HOOD PONDERS ALCHEMY

I grow. I grow. I'm fattening out.
I'm a kid in a rowboat and you're the sea,
the salt, you're every fish of importance.
(Anne Sexton)

It's as if I've been
holding my breath under water.
When I finally let go the fear,

I sleep for Rip Van Winkle years,
and when I awaken, my thirst
is such I can swallow an ocean.

Every three or four hours
I'm so hungry, I could devour
every fish in the sea,

and I need to eat enough
that I don't suffer miserable
waves of nausea.

There's a pushing out of edges,
more than my pelvic shelf—
the boundary of mortality itself—

the point at which
the fathom shifts
from light to dark

as you get deeper down.
Weaving straw into gold
seems less a test

than bringing new life
to term. I'm tethered
to the pull of the moon,

to the lashing
pull of the moon
on the tides of my womb.

THE WOLF PUTS TWO MOONS IN HIS PAINTING *RIVERS OF BABYLON*

> *By the rivers of Babylon, there we sat down,*
> *yea, we wept, when we remembered Zion.*
> (Psalm 137)

My pulse exalts the moons of her eyes,
sweet oasis between her thighs.
Red, a salmon princess driven
into the desert, barely alive,
until our spawning gave her back the river.
From desiccated and forlorn,
she transformed—

no longer her mother's daughter,
no longer her husband's wife—
my lover, though not mine to possess.
Naked as thought, unselfconscious
fecund now, she thrives
with child, unabashed Zionness
bathing in Babylon's waters.

A NEW RED

something breaks inside
And the grapefruit moon, one star shining
Can't turn back the tide
(Tom Waits)

What was scarcely begun,
undone.

The river between my thighs,
a new red.

And if you look into my eyes,
you'll see only necessity,

that mother of us all.
I now know why the Wolf

calls and calls to the pregnant
belly of the moon.

It is too soon to lose
what we never had.

He and I were not wed
to this unborn,

though we will cradle
its red ghost.

The Wolf breathed fire
into my life,

relit my pilot soul,
but the burning spread

from our illicit bed
to the womb.

Now, death flows
slowly between my legs,

branding me with its stain,
this new red.

THE WOLF'S NOBLE ACT

so it is / the shorter story / no love no glory /
no hero in her sky
(Damien Rice)

I knew immediately when Red asked me to meet
her at Grandma's instead of simply coming next door
to my studio, something was wrong.

It is worse than I anticipated. She doesn't need to
speak—
her pale cheeks, her shrunken posture.
I embrace her in my arms, and she says the words I
fear.

"Wolf, I've lost our baby." We collapse
to the sofa, an ocean of salt between us.
"I love you," I whisper, meaning it more than ever
before.

"I love you too," Red sobs—the first time
she's said it aloud. She's so fragile in my useless arms,
a cloud there's no clear way to hold.

I wait for her to find some composure.
Now that our baby is gone, I know
how much I want her, how much I need her in my life.

"Wolf," she finally says, "We had no time to think
what we were doing. All this happened in a blink.
Maybe we need to take a step back—"

"We can have another when you're ready,"
I say, but I can sense Red moving away from me.
"I need some time," Red says,

"to find out what I am, what—" I abruptly interrupt her.
"I can't bear to be apart from you. It isn't right.
You've become the light I paint by."

"I wish I could tell you why..." She falters, tears up again,
"I need to see what's real, find my own way through this."
I realize I'll never know Red deeply enough

to portray all she is. I kiss her
and she responds as passionately as before.
Slowly, I let go of her,

and though I want more—so much more—
than anything to stay,
I stand and leave.

RED RIDING HOOD REFLECTS ON THE AFTERMATH

The moon has nothing to be sad about,
Staring from her hood of bone.
She is used to this sort of thing.
(Sylvia Plath)

If Grandma had only told me,
the secret of life
is to love
the brokenness best,
maybe things wouldn't be a mess.

My whole affair with the Wolf
would have been superfluous.
But I'm not sorry
I climbed into bed with him,
not sorry I said,

"How big your
manhood is,"
nor sorry at his reply,
"The better to satisfy you with."
Could I, would I

have avoided sorrow
for sorrow's sake?
He let me borrow
his innate wildness
until I was able

to discover my own.
In that brief time

Wolf and I conjoined,
love begot what love begets—
an embryo whose goal is growth.

Oh aborted twin,
my subsumed self,
how could I be two
when I had never been
wholly one?

THE WOLF AFTER THE BREAK-UP

"There's in my mind a...
turbulent moon-ridden girl
(Denise Levertov)

All I can paint is white—
white baskets, white snakes,
white woods, white capes,
white apples, white crows,
white flora, white shadows.

Zinc and titanium oxide,
bone calcium, and lime,
everything sublime it takes
to make the white so white,
a witch's brew, rare, true—

as white as the phantom
my lupine heart's become.
White for all that's absent
without Red by my side.
White for all that's not right

without Red in my bed.
A world without Azo,
Bismuth, or buff.
A palette lacking dioxazine,
indanthrene, Naphthol, pyrrole,

and Quinacridone.
Though my mood is saturated
Prussian blue, from all the hues,
the only one I can choose to paint
Red exactly right is moon white.

RED RIDING HOOD ATTEMPTS TO ENLIGHTEN PERRAULT

To comprehend a nectar
Requires sorest need.
(Emily Dickinson)

What breaks your heart
is not the least bit
philosophical.

Lost youth and art break you,
two foxes slipping away
into the underbrush.

A threadbare cape breaks you,
love that cannot be subject to
containment.

Your pencil wavers
between doubt
and wisdom.

Record this—
the scent of him—damp leaves,
the seduction of worry,
a face from a dream.

Mention gas tanks.

What is simple
is never meaningless.

Passion has deep pockets,
feverish streets.

CHAPTER IX

The Continuing Saga

"There are nights when the wolves are silent
and only the moon howls."
(George Carlin)

RED RIDING HOOD REMEMBERS GRANDMA

Grief is a circular staircase.
(Linda Pastan)

She's dead and buried now
and can't speak for herself.
So I'll never really know how she felt
about my romance with the Wolf.

But Grandma believed in taking a chance,
always making bus trips to Atlantic City
to "tickle" the one-armed bandits.
She was the queen of early bird

dinners at the diner and had a healthy
slosh of brandy before noon.
The best advice she ever gave me
was to do whatever it was I wanted

as long as it didn't land me in jail,
(though if it did, call her, she'd make bail).
"Because, Red," she said, "life is
a single shot of malt liquor, last call,

so drink up and have a ball."
And the Wolf, who shared more than a few
brews with her at Hans Andersen's Tavern,
called her "a chewy old bone,"

meaning it as a compliment.
When Grandma passed away, everyone,
even Baba Yaga, showed up at the pub
to lift a mug of lager in her honor.

RED RIDING HOOD GOES DEEP INTO THE WOODS

A woman in harmony with her spirit
is like a river flowing.
(Maya Angelou)

At dusk, I follow two fawns into the wood
feeling myself their invited third.
With every sound, their steps more tentative,
we amble into a clearing and I've a sudden
chilling fear of hearing Hunter's gunshots.

We're easy targets here, yet the pair
lower their heads to sample clover.
The more slowly they chew, the quicker
my pulse. I want us to trail off into the safe
cover of brush. In no rush, they enjoy

their meal in the eternity of the moment.
The deer finally continue on and we veer
into the deeper wood where the growth
is chiefly conifer and ferns.
Should I keep going?

The fear voice in my head warns of getting lost.
A counter voice, more tranquil, says remain aware,
travel in the direction of restorative breath.
This doesn't make much sense.
I even look around to see if the sound's come from

someone else. No one's here but me.
The fawns have slow-stepped out of sight.
Should I go where my breath will lead?
I go farther and farther in, territory
I've never been before, not even as a child.

Human noise utterly dissipates,
no Doppler effect of interstate trucks,
no airplanes thronging overhead.
Just the rhythmic thrum of forest life—
toads, crickets, beetles, night

warblers, thrushes, and many more
I've never heard or never learned to name.
The air darkens. Time slows.
After a while, I come to another clearing,
circular, with seven tall balsam appearing

to stand sentry around its boundary.
I go to the center and look up.
The moon is tucked in a shroud of cloud, stars,
like phosphorescent fish, occupy the marine sky.
Constellation Pleiades is clearer than ever before.

Her swirling huddle of stars is really millions,
not just the seven that seem to wink at me.
I'm thinking what a blessing it must be
to be allied with so many sisters,
when I hear breathing not my own.

Across the clearing I see a figure—
a timber wolf with silvery fur.
A pair of gleaming eyes meet mine,
and I'm surprised by the creature's
nearly human size.

The moon slides out from cover and I see
it's not a wolf at all, but an old woman
with glowing skin
and flowing silver hair—
total grace and loveliness, coming closer.

Just before we're nose to nose,
two things happen at once—
the moon redoes her shroud
and the woman collapses to a pile of bones.
I question my sanity,

then whirl around to see if somehow
she passed beyond me.
But there is no sign of a wolf or a woman.
So I kneel to examine at the bones,
turn a few over in my hands—

small, curved, purely white,
glowing slightly.
Not knowing what else to do,
I fill the pockets of my cape
with these natural treasures.

The moon returns, full and bright to light
a path out. As I go, my fingers brush
a cedar tree and I can feel
a gouged-out mark—the arch
from my dream of fortnights ago.

I have no idea what this all means.
Instead of shivering, my body feels
energized and warm in the night air.
I step intuitively toward home,
serenaded all the way by a Whippoorwill.

RED RIDING HOOD ADMITS
HER OWN COMPLACENCY

may you kiss / the wind then turn from it
certain that it will / love your back
(Lucille Clifton)

I might have said it was Hunter
holding me back,
Mother's holding me to tradition.
But the idea of autonomy was more
fearful than I could admit,
complacent in my wifely role,
complacent dolling out milk
and cookies to my daycare kids.

Too stuck in a rut to recognize
my misery, and beneath it, a lurking behemoth
fear of inadequacy, fear of not being enough
to be anything but helpmate,
baker of rhubarb pies,
ironer of sheets,
lullaby-er for little ones
with tales to soften the dark.

It turned out self-knowledge
wasn't an apple
I had to pluck from
some forbidden tree—
it was a seed already alive
in me that had begun to sprout
the day I ventured out
to the art museum.

Near fainting before
the dancing painting of Salome,
I witnessed seven souls—
wise old Baba Yaga, beauteous Briar Rose,
whirling dervish Kali, Eden's naïve Eve,
sin-eating Tlazolteotl,
nourisher Auset,
and compassionate Arya Tara,

I witnessed seven veils unpinioning
from the divine chalice
of woman's womb-chasm,
seven powerful feminine identities
midwifing into one—
this one—
this new Red
I am becoming.

RED RIDING HOOD VISITS AN AQUARIUM

You are too much my lover.
You would put yourself
Between me and song.
(Edna St. Vincent Millay)

The Wolf Eel is a sad looking creature,
the head of a bald eagle, the body of
a blue-spotted snake. If Wolf were here
he'd quote those lines from Blake—

The poison of the Snake & Newt
Is the sweat of Envy's Foot.
The poison of the Honey Bee
Is the Artist's Jealousy.

There doesn't seem reason for envy here.
This sea serpent wolf is said to mate
for life, but except for a roach-like Chiton,
he's on his own in that dank tank.

His tiny ink-drop eyes so black
they seem to swallow all the light,
reflect nothing back, and if not
for a nervous-seeming quiver

of his jaw, I would think
him not a living thing at all.
One can see as he breathes,
a mouthful of baleful teeth.

In this fake aquarium reef,
his wildness has been thieved.
I watch a diver feed him tiny fish,
stroke the head of this lonely beast.

I wonder if the Wolf still thinks of me,
or if he's already forgotten about his Red,
moved on to bed a new artist's model.
Would our union have been able to last?

Behind the glass of the next tank,
a China Rockfish hangs on the wall
like a bright blue-handled iron
awaiting some housewife's next need.

The placard reads, "These solitary fish
never venture more than thirty feet
from where they are born."
I guess I used to be a Rockfish

in my former life. Or maybe more like Red
Octopus, who despite his Devilfish nickname,
is truly shy and would rather hide by folding
up into the tightest spaces than meet your eyes.

Or is it merely that Rockfish treasure solitude,
just like I have come to take such pleasure
in my own? And perhaps Octopi are fond of
ruminating about what artistic new shapes

they'll soon sculpt themselves into.
These Moon Jellyfish are artists too, ballerinas
of the sea, but delicate and prone to injury.
I could watch them for hours,

narrowing and expanding, billowing
their frilly, iridescent, transparent selves.
Should I have been more clear
with the Wolf about my fear of losing

not only him, but my newfound sense of self?
I could have made it understood how much
I cared for him, but didn't think it right
to rush into another committed life.

I must trust my intuition more, not second guess.
These poor floor-dwelling Starry Flounders
spend so much time on the bottom staring up
their eyes migrate to one side of their heads.

They remind me of the Picasso-esque painting,
"Shaving Man," Wolf and I saw, who so resembled
my husband Hunter. Flounder surely must be
the egotists of the ocean or else just very lazy.

And what about these Sunflower Stars
with hazy vision who see light
and dark, but can't distinguish imagery?
Life to them must be a constant abstract

painting—*white over black.* Oh, that Wolf,
I wouldn't take a moment of us back.
You made me conscious of the fact that I
contain multitudes, more fathoms than the sea.

RED RIDING HOOD EMBRACES HER ARTIST ANIMUS

I shall gather myself into my self again,
I shall take my scattered selves and make them one.
(Sara Teasdale)

I must find the bones,
a library of bones,
bind them together.

These bones are concrete clues,
loose, chipped away,
split apart,

forgotten treasures
buried for the sake
of sacrifice.

These bones are truth,
are essence.
When I have enough bones

I'll uncover endless ways
to make sense of them—
carve and cut,

thread and brace,
solder and set—
hold them up whole, anew.

I'll fashion passionate
conflagrations of bones,
spark bones into

wolf-woman configurations.
Harrow every bone, and by this
know myself to the marrow.

I will sing over the bones,
string bones along necklaces
of strong song.

From my brazen red-hooded
heart, I'll sing and thrum
every bone with ringing anthem.

RED RIDING HOOD HOWLS IT LIKE IT IS

The soul's bliss and suffering are bound together.
 (Jane Kenyon)

I would have preferred
it was Grandma, Gretel,
or even Baba Yaga
who finally set me straight.

Not a Wolf who, leading me astray,
actually got me going the right way.
But at least Wolf is more anima
than he is masculine male.

So, at last, my tale is finally told
uncensored, unexpurgated.
There is illicit sex. So what?
That isn't the point. Listen.

Let me be *She* who sounds the alarm,
She who undoes conformity's harm.
Not princes' kisses at all, but siren *She*
with the song that at last wakens

other voiceless heroines to arise
from the ether of acquiescent sleep,
the poisoned keep of expectations' bonds.
She who bites the apple and gains paradise.

RED RIDING HOOD A YEAR INTO HER LIFE AS ARTIST

I came to see the damage that was done
and the treasures that prevail.
(Adrienne Rich)

I used to envy those women in romance
novels, the exotic places they dashed
off to, the men who expended all that
energy falling in love with them.
No more. Now my heart tells me
where, my feet lead me there.

I have been out on backroads alone,
zigzagging the sun-spilt countryside
finding sundry pieces for my art—
bones and burls, seeds and oddments.
I'm making friends in unlikely places.

At a hardware store in Moses Lake
a Quaker woman reminds me being
still isn't the same as silence. Inner peace
requires being quiet enough to
let the soul speak. I'm listening.

I'm harking to wind and wildlife.
To that sky over Wolf Point, Montana
that sighs mightily at dusk, to those
midnight breezes carrying musk of a day's
hard labors, the dust of tired hooves.

On my way southeast now, having seen
the sea and rinsed my skin in salt-spray,
having tasted Pacific rain and Rainier snow,

I warm my red-cloaked hide over fires
banked in red clay and sandstone valleys.

I'm heading home again through Wyoming,
to the place where three rivers interlace, where forest
deepens with Limber pine and timber-wolf-woman spirit.
If you go there, kindly find me by the welcome sign I've
 honed
from salmon scales, reclaimed bones, and sea glass, and
 say hello.

LONE WOLF TAKES OFF FOR PARTS UNKNOWN

In this world love has no color yet how deeply my
body is stained by yours.
(Izumi Shikibu)

All alone, I could no longer
lay color on canvas
as I once had when Red,
my singular muse,
stood by my side,
the love in her eyes,
the one guide I needed.

You might say,
I lost my way
after I lost her.
I couldn't find a path
back to my easel,
my head empty
of all images but her face.

I found no grace
visiting art museums—
sad, dusty spaces
full of cavernous
echo, but empty
of the sound of her
melodious laughter.

Grief, that obsessive song,
played over and over,
stuck in my head,

a lovelorn blues.
I had to get moving,
outrun the tune.
So I drove the interstate

in a zombie-state,
oblivious to the wonders of
the open spaces I raced across.
Escaping all the places
Red & I had been as one soul—
the only goal that
kept me going, kept me alive.

HUNTER LANDS IN HOLLYWOOD

Coming to ABC this fall, *Lumberjack In Love*, a new show where heartthrob woodcutter Adam Hunter searches for his one true tree-sprite sweetheart among a group of thirty-six tempting Yakshinis. Will he be fooled by malevolent maiden deities pretending benevolence? Will Hunter find love, and if he does, will she forgive him for felling trees or punish him for being the timber killer he is? Anything can happen on this thrilling season of *Lumberjack in Love*. Tune in for some hale fairy tale fun.

RED RIDING HOOD'S MOTHER FINALLY WRITES HER AN EMAIL

I know it's been years since I wrote you, but I promise to send a note once I'm home. Right now, I'm stranded in Rome without a Lira or Euro to my name. Won't you be my hero and send me some money? Honey, I've been robbed of my wallet and passport by a handsome fellow tourist, and the hotel's holding my luggage hostage until I pay the bill in full.

I need relief, so don't give me any Red-caped grief about not trusting strangers. Like you, I knew the dangers. What's life, but a wild adventure? Sometimes the Wolf is just a sheep who's made more promises than *she* can keep.

In my case, to save face, I need to tip the waiters well and often, and keep the coffee beans flowing, if you know what I mean. More espresso, please.

Mama Bear's jonesing for some bones, sweetie, so wire your cash to the address below and tweet your love to hashtag *imnohag*.

A YEAR AFTER RED RIDING HOOD LEFT HIM
THE WOLF RECLAIMS HIS PALETTE

Only one mountain can know the core of
another mountain.
(Frida Kahlo)

Exploring nature's realm once more,
across Wyoming's endless canvas,
I rediscover a door to belonging
to myself—liberating inhalations,
wind to the blades of grass
my lungs are, beast beat of my heart
before it wailed for Red's return.

My yearning for Red is like a broken
vessel of my blood. It will heal here.
There is sacred power at Devils Tower,
this lodge where all creatures can be
as in love with their elements
as with themselves. And so I bay,
singing to the great source of all being.

I bay here at this place not to weep,
not to beseech, but to praise, to raise
my voice with joy. And when I paint
it will not be out of regret, not to forget,
but to celebrate myself, my love for Red,
celebrate being able to love her still,
and more, and not this lone life less.

I sing the bliss of this potent space, this rock face
extruded from earth's volcanic heart, eroded by
centuries' dispassionate abuse. I sing all hues of oil.
I use fire's loyal tones—bloodshot copper, terra cotta,
cadmium. I lay down time's royal blues—beryl, basalt,
slate. The sky I shade with weightless whites and grays,
the moon's serene face I paint rosy above the tower's height.

THE WOLF MOVES INTO THE SECOND STAGE OF GRIEF

No one ever told me that grief felt so like fear.
(C. S. Lewis)

The night I arrived,
moonlight shone
over Devils Tower,
illuminating that sacred space,
and nature reawakened
my spirit, my feral instinct
to make art.

My heart swelled with
the goodness of the earth
and I bayed a song of celebration.
Greif quelled, all well again,
wild rivers of temperas
flowed from my hands
across my canvases.

With each brush stroke,
rosy new skies blossomed.
Every day, I woke to work,
every night I raised my voice
in praise of the landscape.
I thought myself achieving
my greatest oeuvre.

Then, out of the blue, the heavens
raged like the verdict of a god
denied adulation,
a tempest descended,

flushed the blush colors
from my paintings.
A cleansing rain revealed

the brutal truth—
after great loss
beauty becomes assault.
I was worthless without Red,
all my art false,
worse than fairy tale.
Trembling with fear,

grief burned in me again.
What the storm started,
I finished—ripped my paintings
from their frames,
slashed them to shreds,
flakes, dust, until nothing
recognizable remained.

CHAPTER X

Ever After

Because the night you asked me,
the small scar of the quarter moon
had healed — the moon was whole again;
(Linda Pastan)

RED RIDING HOOD AT HER SEASIDE CABIN

Beautiful young people are accidents of nature,
but beautiful old people are works of art.
(Eleanor Roosevelt)

Outside my windows the Pacific
defies its name, whipping and whirling,
rolling peaks of furious foam.

I wish to remain within
my cozy cabin's weather-
faded wooden walls,

where I have meditated on
the path shadows sweep across
the floor as the earth lightly turns.

I want to sip my licorice tea
and tip a toast to the sea,
with its infinite hues of blue-green,

so many, I will never
see them all in my lifetime.
I am worn, and worn out,

and something in this morning
feels a warning of change,
when sameness suits me so well.

I have found my way here
to this craggy coast
by traipsing every landscape

from forest, to high desert, to Palouse,
and finally landed where movements
of sky, wind, and water

are a never-ending soul symphony.
My paintings are such simple sonatas
in the collective ever-evolving song.

Yet I am grateful to play my notes,
my fondest hope—to keep arranging color
on canvas until death takes my final breath.

THE WOLF DISCOVERS HIS MUSE
ANEW IN WALDPORT

Unshaven, threadbare,
on his usual way nowhere
in particular, Wolf
stops off for coffee
and a newspaper at a coastal town.

He nearly drowns in lukewarm java
when he sees the face
that graces the front page
of the Yaquina Woods Gazette—
Eve Hood, his Red.

Though he's memorized
the sunrise of her eyes,
the sly surprise in her smile,
there's some new expression too—
composure, knowing?

The local library's holding
a retrospective of her work,
so he wastes no time
finding the place—
and dare he hope, her?

Would she even care to know him
now, or want to say hello,
she's so successful
having moved on so fully
without him?

He hesitates under the portico,
peers in the window.
Is she here?
Blood thrums drums of fear
in his ears, but he enters.

From the back wall, landscapes,
all pointillist technique
in gradients of hue saturation,
seem to undulate within
their frames, aflame.

The coastal range mountains dappled
with rain, the cows marching
toward the barn, the muddy boots
akimbo on the farmhouse porch—
all torched not by heat,

but quantum dots of paint.
Up close at the first canvas,
he admires her restraint,
her patience, her prowess
with complementary colors,

when out of the corner
of his eye, he spies the figure
of what might be a wolf.
But it dissolves as he tries
to perceive it directly.

Blood rushing through his veins,
he varies his angle of viewing
until he sees the *anamorphosis*
wolf again—broad, dark,
brandishing a paintbrush.

She hasn't forgotten me.
And sure enough,
that same artistic wolf
appears in every one
of her artworks, hidden

from casual observer,
but impossible not to see
once you look with
divine intention.
She still loves me.

His solar plexus shifts,
the mantle of grief lifts from his heart.
He swiftly leaves the library,
lightness in his step.
I will make art again.

From imposter to *Impasto,*
he sees the possibility for assemblage,
for dimensional collage, to create from
the slashed shreds of his longing
for Red—at last—love's resurrection.

RED'S FRIEND GRETEL FEEDS THE HUNGRY

The hunger for love is much more difficult to
remove than the hunger for bread.
(Mother Teresa)

The famine of parental care
in her childhood home
gaunted Gretel into adulthood.

Her heart starved for regard,
she fed herself on sex
with lover after lover,

discarding them whenever
they showed true affection, certain
she was too fat to deserve it.

I strived to convince her
that her worth as a person
had nothing to do with her girth

(or lack thereof), but with her goodness,
humor, compassion, her tender care
for her brain-injured brother Hansel.

Nonetheless, she tried every fad diet,
every girdle and waist slimmer gimmick
to look thin and Hollywood-ready.

Eventually, anorexia rendered her
skeletal, and very nearly ended her life.
I worried nothing could heal her.

But when a social worker suggested
Gretel volunteer at the local soup kitchen,
something wonderful happened.

Gretel discovered a new
relationship with nourishment.
Not food as the enemy of love,

but food as respect.
The homeless who came to fill
their bellies were not only hungry,

but condescended to
as if they were less than human.
Among them were everyday folks

who became Gretel's friends—
a perennially out of work actor,
a retired philosophy professor

who never made tenure,
a plumber who sprung a leak
of luck early in life when his truck

and tools were stolen
and he lacked insurance,
a therapist who lost his license

for prescribing sunshine
and forest air, rather than
side-effect ridden pharmaceuticals.

Now Gretel has a new lease on lunch.
She's been known to lick a plate
spotless, pick a whole roast chicken clean.

She's enrolled full-time in culinary school.
Hansel helps her with her cuisine homework.
Her dedicated sous-chef,

he chops carrots, onions, and celery
for the mirepoix, happily taste tests
all Gretel's scrumptious pastry recipes.

BABA YAGA WAXES NOSTALGIC

Listen, young one, I was young once too,
hair softer than mouse whiskers,
toes smooth as rose blossoms.

No one feared me then,
just cooed over me
as if I were a common fool.

Now my broom-thistle crown
and horny-bunion feet arouse
disgust, which I know

is only a cover for terror.
Oh, once I inspired lust,
a girl as pretty as you

and as powerless.
But I was more clever
than all the gods in heaven.

I siren serenaded them,
made them so hot
for me, they perspired fire,

gave away its secrets
so only I knew
how to tame the flames.

I tricked them all
with my demure calls,
all the while holding up

a mirror to their desires.
I kept my maidenhood
intact and sired

my own conquest dreams.
Yes, I eat alone at my table,
queen of my home,

queen of this entire wood.
And although I eat alone,
I feast.

Can you say the same?
The tow-haired girl
at Baba Yaga's feet

to whom she's speaking
does not answer right away,
remains silent.

It seems that all that's left besides
her blonde locks is a pile
of bones sucked marrow-clean.

RED RIDING HOOD AT THE CHEESE FACTORY (NOT A TRYST)

As it turns out, now is the moment you've
been waiting for.
(Lucinda Williams)

A beleaguered March day,
wind throwing tantrums,
sky refusing to cry,

but sulking in every shade
of despair,
I arrive at the cheese factory.

My heart in my throat,
I know I don't want to go in.
But there's nothing to hide from.

Wolf won't be here,
only his latest creations,
hybrid collage-paintings

in the *Impasto* style,
thick with wild
pigments and dimension.

Nothing to fear here, where
the tourists come for soft-ripened
cheeses that please the palette,

cold cones, piled high with sweet
creams to delight children
and adults alike.

School buses line the parking lot
like tidy groves of goldenrod.
Odd that I haven't become a regular

these many years since settling
into my salt-bleached shack
within sightline of a sea-stack,

a titan fin rising above water.
I've painted that biteless predator
enough times to name it friend,

though each rendering
falls short of what I intended,
and some have hung on these same

cheese factory Creamery Gallery
walls as Wolf's works do today.
After a deep breath, I make my way

into the visitor center, expecting
the expected—cow-themed trinkets
and t-shirts for sale, cases of delectable

dairy treats, crowds of earnest faces.
And that's what I see
until my focus narrows, zeroes in

on a dazzling family group—
strawberry-blonde model-type mother,
lean, clean-cut naval-officer father,

two wild-haired redhead little girls,
each holding a hand of the second male
who stands in silhouette—

190

a lupine profile I will never forget.
My heart plummets to my stomach.
Does *this* me want to meet the Wolf again,

this Red, decades different,
capeless, aged, and alone?
As if by instinct, he gazes

in my direction, a guileless smile
and wood-smoke eyes,
and everything in me says Yes.

The Wolf lopes closer, close,
all taut haunch, feral insinuation,
and I know there is no turning back.

RED AND THE WOLF, AN AWKWARD RE-INTRODUCTION

And how can you not forgive? You make a feast in
honor of what was lost...
(Jane Kenyon)

Feeling herself plucked from real life,
stuck in some Hieronymus Bosch nightmare
of a cheese factory tourist trap gone awry,

Red faces her former lover the Wolf,
still magnificent in stature,
and his equally gorgeous young brood.

"This is my brother's son, Sam," Wolf says
indicating the handsome naval officer
who bears him more than passing resemblance.

"And his wife Bella," an aptly named beauty.
"And these, my nieces, Joy and Hope,"
he says, shouldering the freckled, giggling girls.

At a loss, Red relies on her manners.
"I'm so pleased to meet you all.
You must be so proud of your uncle's fine art."

"We are," the nephew says,
"But who the blazes are you?"
"I'm so sorry," the Wolf says, bowing

to his kin. "This is Eve Hood, my Red."
His Red, she thinks, as if the decade plus
years since they've met amount to

no more than a blink.
His Red, as if she could not belong
to herself, or belong with anyone else.

"So you're an artist too," Sam says.
"Uncle Frank's shown us photos.
Wish we could stay and chat,

but we're bringing the rugrats
to their Grandma's now."
Hugs and kisses all around,

the family takes their leave, leaving
Red and the Wolf alone together,
silent among noisy tourists, but smiling.

IN THE PARKING LOT OF THE CHEESE FACTORY THE WOLF ASKS

I have been to hell and back, and let me tell you it
was wonderful.
(Louise Bourgeois)

My precious Red,
I saw the show
of your pointillist works
in person at that library
down the coast.

Ever since then
I believed with every
cell of entire being,
we'd meet again,

that you would be
unchanged as rain,
but new as waves on the sea,
energized and luminous.
And I see now that is true.

Red, you are more
beautiful than I recall,
lovelier than any painting
I've since made of you,
and there have been many.

The only changes I note,
are your red trench coat
with belted waist,
which suits you better
than your old formless cape,

and the slightest hint
of silver moonlight
glowing in your hair
that wasn't there before.

I'm sure, to you,
I look worn, forlorn,
but just lately,
I've been content.

When I discovered a wolf
hidden in all the wonder
of your paintings,
I knew that you
still thought of me.

That knowing filled up
the void my heart had been
and brought me back
to myself and to art,
renewed.

Prior, I discovered hell
was my regret over
not chasing after you
when you left town.

Hell was not knowing how
much I needed your intellect,
your fresh perspective
to daily flip me on my head.

I want you to know
my suffering wasn't all
about missing you in bed,
though that too was hell.

Making love to you
is love in its purest flesh.
Sleep is deeper by
your side, the world better
waking through your eyes.

Hell was not telling you
all I felt, how incomplete
my life without
the nearness of your soul.

But it was hell that made me
see clearly, truly cherish
the marvel you are.
So hell brought me
to the grace of wisdom.

And now we are face
to face, as close
as the space between
heartbeats,

I never want to occupy
any place where you
and your heart
are not.

This is not the most
romantic spot to ask,
among the yellow buses
like caterpillars
filled with butterflies,

but Red, I'm looking deep
into your eyes to beseech
you, tell me there is
no one else, that you are
free to embrace me,

free to be the love
within my arms
once more,
in this moment, now,
and for forever after.

RED SIDESTEPS THE WOLF'S REQUEST
FOR EVER AFTER

*Once you lose someone it is never exactly
the same person who comes back.*
(Sharon Olds)

You need to know I'm sorry—
so sorry—for leaving without
so much as a note.

Once I decided to go,
I worried I'd lose my nerve
if I stopped to say goodbye.

I had gone from my mother's home
to Hunter's cabin without ever
really being on my own.

I had no idea what to do with
myself all alone, without owing
something to a parent or a man.

I needed to be free to discover
what I wanted to be
when *I grew up,* so to speak.

You gave me a head start,
teaching me so much about art,
showing me the various mediums.

Every day of being away,
I missed you,
I missed the baby we lost.

I never knew what love
truly was before you—
a blessing and a curse.

But what was even worse,
was that I'd also been told
I'd never be able to conceive again.

Depriving you of fatherhood
was more than I could bear.
I traveled too, to escape that news,

to distract myself with new
surroundings, to focus on
things external to myself.

I sketched my environment,
experimented with various ways
of laying down oil, pastel, acrylic.

I tried out new surfaces and substrates.
The floodgates opened once
I reached Wyoming—something

about the sacredness of place.
And maybe, too, I saw your face
everywhere I looked, or placed you

in every landscape to counter loneliness.
Creating became my entire identity,
and before I knew it, I was traveling

across the county intuitively,
following the lead
of my heart and art.

Deep inside, I held the hope
that inserting you in all work
kept me close to you in your world too.

As the years passed, I grew content
to let you be the love of my life
I'd never see again in person.

I kept track of all your art shows,
observed how your work evolved,
became ever more accomplished.

I was happy for you, wished you
every happiness too, but never would
let myself believe you could need me.

Oh, Wolf, I hardly know how
to answer you now, except to say
let's get reacquainted, spend some time,

see if you still find me appealing
once you know who I've become.
But this I tell you, real and true—

I have never stopped,
nor will I ever stop
loving you.

RED DECIDES AT THE AIR MUSEUM

How silently the heart pivots on its hinge.
(Jane Hirshfield)

The largest clear-span wooden structure
in the world, a rising feat of architecture,
that once housed blimps, now a museum
of aircraft, stands as monument
to ingenuity and perseverance.

Sadly, the roof leaks, puddles pool
over the concrete floor, and dankness
prevails, but echoes of purpose
and determination hover above
the historic planes

with names like Banshee, Hawk,
Stiletto, Sky Night, and Bird Dog.
And no trick of the overhanging
shadows, are the enterprising owls
nesting in the rafters.

Cheery forties music pipes in
through crackly speakers
as the Wolf and I make our way
to the display of our first
collaborative works—

In Praise of Lift, a series
of five paintings exploring
metaphoric and actual flight.
They line the wall just past
the Helium Room

where the gas was purified
for use as lift in the once
grand military balloons.
Despite the low lighting,
our paintings glow

with angels, insects, rockets,
the Wright Brothers, fighter jets,
blimps, birds of every feather,
butterflies, bats, kites, flotsam
the wind takes aloft,

joy, poetry, love, music, and other
abstract ways of soaring.
In the weeks since we found
one another again, we've
hardly been apart.

Working on our art together,
and separately, but side by side,
the Wolf challenges me to see
the world anew each hour,
empowers me

to be bolder in every stroke.
In this cavernous dirigible hanger,
I feel I'm finally ready
to make my reply to the Wolf's
ever after proposal.

My safe harbor escort
in the precarious waters of this life,
my challenger, cheerleader,
co-conspirator, he continually
makes my heart take flight.

202

Wolf, I say, *will you stay with me*
forever and a day?
His *Yes* howls, rises, ricochets,
reverberates throughout the air museum,
our betrothal a sweet, sweet sirocco.

RED AND THE WOLF STROLL THE BEACH

You have come to the shore.
There are no instructions.
(Denise Levertov)

This is like no seascape
you've ever seen.

The sky is dull as dirty mop water.

A faded orange pail
lost of its shovel
hovers at tide's edge.

The mottled beige sand
scattered with broken shells
no one wants to collect.

Waves too wild for swimming
break precariously near an unaware
couple who roam the beach.

The weather is blustery raw
and it begins to rain big, sloppy
drops of slush.

Nonetheless, the careless pair
dip their toes
into the frozen seafoam.

Perhaps, they have no common sense.

Perhaps, they are fools
who fritter time.

Perhaps, their only crime
is being ordinary,
like the rest of us.

Or perhaps, they are extraordinary,
as we all are when love
rules our circadian rhythms.

RED RIDING HOOD ON THE SOUNDS OF A COMPANIONED LIFE

as some strings, untouched,
sound when no one is speaking.
So it was when love slipped inside us.
(Jane Hirshfield)

The whoosh, whoosh, whoosh
of salt spray stinging our faces
awake as we say good morning
on the sea-facing deck.

Hiss of coffee steam
as he pours me
the day's first bracing cup.

My turn to shower,
the plop of the bath mat
dropping to the floor,
already damp.

Bassoon tune of the Wolf's laughter.

At the kitchen table, his hums
as he works oils into image.

The clatter of his crock pot
on the stovetop, stocked with
a chicken dumpling dinner for two.

The dusk candles *sissing*,
lit before I have to ask.

The plink-plink,
plink-plink
of rain straining through
the muck-filled gutter
he's still promising
(for the umpteenth time)
to clean out.

When he sneaks up behind,
leans in and kisses my neck,
tingly, wet *mmuuhs*.

Stout baritone snores
just a pillowslip away.

EPILOGUE: HAPPILY EVER AFTER

*Little Red Riding Hood was my first love. I felt that
if I could have married Little Red Riding Hood, I
should have known perfect bliss.*
(Charles Dickens)

After the prince and maiden kiss,
the story doesn't truly end
with a lifetime of bliss.

Not bliss, but glass-slippered blisters.

The story continues long after
you lay down the book,
the royal pair having said *I do*
believing all will stay true.

Later, there are tough times
where bitter tongues prevail.

Fixity is *the* fairy tale.

Ever after
are the unexpected trials
that need fixing—

> The drain that monthly clogs
> with Rapunzel's fair locks.

> Sleeping Beauty's chronic insomnia.

> The seven dwarfs having to sign up
> for unemployment compensation
> after environmentalists shut down the mines.

The Frog Prince's continued culinary preference
for flies even after resuming human form,
causing his bride to insist he brush his teeth
before she'll even consider kissing him.

Ever after is the brokenness
you can't fix,
but learn to live with—

Snow White's skin cancer
forcing her to remain indoors.

The carriage crash that leaves
the prince with a limp,
so his waltz is more of a heave-ho
than a here-we-go.

Elderly Cinderella scattering her shoes
all about the palace
out of forgetfulness.

Boastful Rumpelstiltskin's arthritic fingers
obliging him to switch careers,
trade in his spindle for a mic,
swindler turned TV shopping channel host.

Happily ever after hardly ever happens,
unless the lovers die upon love's consummation.

Paths diverge, lovers tire of one another.
Hot-n-heavy goes cold with
three kids under five in the household.

The handsome hero grows nose hair,
becomes hard of hearing.

The fair maiden turns out to be infertile,
unable to conceive the king an heir.

Fairy tales aren't fair.

They end when things
are just about
to get vexing—

> Frozen pipes, colic, toothpaste squeezed
> from the middle of the tube, who's turn it is
> to take out the trash, don't leave your laundry
> all over the floor, that's what the hamper's for.

Happily ever after? Who are we kidding?

Only Baba Yaga, unpartnered, remains unchanged,
alone in the woods in her chicken-legged home,
scheming ways to trick the lovelorn
into doing her terrible bidding.

The drudgery of ever after life
creates a million new grudges.

The best we can expect?

Happily ever after moments,
doled out haphazardly,
throughout a lifetime—

> In the dark movie theater,
> the princess plants a kiss
> atop Prince Charming's
> long bald pate.

On Mother's Day, Cinderella
discovers the dinner dishes
already rinsed and loaded
into the dishwasher.

Snow White's husband
begs her to quit the Botox
because she'll always be
the fairest in his eyes.

After Red Riding Hood reminds him
several thousand times, the Wolf finally
leaves the toilet seat down for her.

Far from profound,
real life's *ever after* happiness.

And the alternative to happily ever,
happily never—
like disaster—
happens all the more frequently too.

So what's a romantic to do?
Give up on fairy tales
because happily ever after
isn't true?

The best advice—

Live like Jack Spratt and his wife,
where opposites are compliments
not bones of contention.

Dole out the bones from the cupboard
to Mother Hubbard's Cocker Spaniel,
or else prepare a hearty broth for two.

Listen—this is the truth:

 Love is not a holiday
 or a happily ever after.

 Love is daily labor.

 Love's daily labor rewards
 its loyal workers
 despite lean and fat,
 regardless of youth or age,
 through trauma and betrayals.

 Love's labor pays
 in love
 that stays—
 love.

This really the best
ever after any of us
can wish for in this life,
even the great
Mr. Charles Dickens
who wished for a fairy tale wife.

ACKNOWLEDGMENTS

Appreciation to the following fine journals and wonderful small presses for publishing my poems, sometimes in earlier versions:

2010 Rhysling Anthology for "The First Story" which was nominated for the coveted Rhysling Award and took 3rd place.

American Mythville for "Red Riding Hood Considers Alchemy," "The Wolf Puts Two Moons In His Painting, Rivers of Babylon," "The Wolf Guesses Red Riding Hood's News," "A New Red," and "The Wolf's Noble Act."

Art Access for "The Wolf After the Break-up."

Boiling River Review for "The Wolf Admits His Weakness."

BlossomBones for "Red Riding Hood Visits An Aquarium."

Centrifugal Eye for "Red Riding Hood Dreams Of Another Winter" and "Red Riding Hood Paints While the Wolf Sleeps."

Chicken Piñata for "What Red Riding Hood Realizes."

The Dirty Napkin for "The Wolf the Morning After."

Hotmetal Press for "Prologue: The First Story," "Red Riding Hood Dreams of the Wolf," "Red Riding Hood Dispels the Myth of What Big Teeth," and "'Red Riding Hood Kisses, Tells All'."

Jack Straw Writers Anthology for "Red Riding Hood Talks About Her Mother," "Red Riding Hood Dreams of the Father She Can't Remember," and "Red Riding Hood's Real First Encounter With the Wolf."

Kissena Park Press, with deep gratitude to the wonderful Jeff Gomez and Chrysoula Artemis for going along on this romp through the woods by publishing my chapbook, *What Big Teeth.*

Naugatuck River Review for "The Moment Red Knew."

Pecan Grove Press, with earnest thanks to Palmer Hall for his faith in Red, and for publishing many of the poems here in my collection, *A New Red.*

Poemeleon for "Baba Yaga Advises Red Riding Hood."

The Poetry of Marriage Anthology for "Hunter Insists On Having His Say."

Redheaded Stepchild for "What the Wolf Told A Bartender About Red Riding Hood."

Red Oak Review for "Red Riding Hood After A Second Tryst."

Soundings Review for "Red Riding Hood Confides In Grandma" and "Red Riding Hood Meets the Wolf A Second Time."

Stimulus Respond for "Gretel Advises Red Riding Hood."

Umbrella for "The Wolf Reflects On His First Meeting With Red Riding Hood."

whispers & [Shouts] for "Red Riding Hood Ends Up With Hunter."

GRATITUDE

Deep gratitude to Hedgebrook, especially Amy Wheeler, for gifting me radical hospitality deep in the woods and the sisterhood of women writers.

Sincere thanks to the Helen Riaboff Whiteley Center, especially Arthur Whiteley, Kathy Cowell and Aimee Urata, for the sanctuary to bring much of this work to fruition.

Hearty thanks to the Jack Straw Writers Program, especially Joan Rabinowitz and Donna Miscolta, for their support, and of course, thanks to my fellow Jack Straw Writers.

Earnest thanks to Patricia Lillie, Lori A. May, and Annette Spaulding-Convy for their careful eyes.

Eternal gratitude to Ottone "Ricky" Riccio for greeting me at the threshold of poetry and welcoming me in.

Everlasting gratitude to my 3rd grade teacher, Mrs. Sarfaty, for kissing fuchsia lipstick wings on my cheek and dubbing me a poet.

Profound appreciation to Patricia Fargnoli for her generous feedback, friendship, and perpetual belief in me.

Boundless gratitude to artist Marie Fox for allowing me to use her marvelous painting *Morning with Matisse* on the cover of this volume.

Bottomless gratitude to Tonya Namura for her brilliant book design.

Heartfelt thanks to my family of writers and friends, especially the Striped Water Poets, my Kingston critique group, as well as James Bertolino, Anita K. Boyle, Jeannine Hall Gailey, Natasha Kochicheril Moni, Nancy Pagh, Linda Warren, and Julene Tripp Weaver. I adore you all.

And last, but never least, loving appreciation to my husband Andy for allowing Red and her troupe to come bunk with us a good long while.

ABOUT THE AUTHOR

Lana Hechtman Ayers, originally from New York, lives in the Pacific Northwest, where she works as a poetry publisher, facilitates Write Away™ generative writing workshops, leads private salons for book groups, and teaches at writers' conferences. She is obsessed with exotic flavors of ice cream, Little Red Riding Hood, and monochromatic cats and dogs.

Lana earned Bachelor's degrees in Mathematics and Psychology, and holds a Masters in Counseling Therapy, as well as an MFA in Poetry and an MFA in Writing Popular Fiction. A Hedgebrook alumna, Pushcart Prize and National Book Award nominee, she is the author of several collections of poems, including *The Moon's Answer* (2016, Egress Studio Press), *A New Red* (Pecan Grove Press, 2010), *What Big Teeth* (Kissena Park Press, 2010), *Dance From Inside My Bones* (Snake Nation Press, 2007), *Chicken Farmer I Still Love You* (D-N Publishing, 2007), and *Love is a Weed* (Finishing Line Press, 2006). She is currently at work on several speculative novels.

In addition to thriving in the book-loving culture, Lana enjoys the Pacific Northwest's bountiful rain and copious coffee shops. She is a movie addict, a time travel enthusiast, and watches entirely too much Home & Garden television. Her favorite color is the swirl of Van Gogh's *Starry Night*.